THE FOOLPROOF
METHOD

How to Draw
a
CHARACTER

THE FOOLPROOF METHOD

How to Draw a CHARACTER

Soizic Mouton

ST. MARTIN'S GRIFFIN
NEW YORK

To my mom,
who taught me to watch,
and to take note

CONTENTS

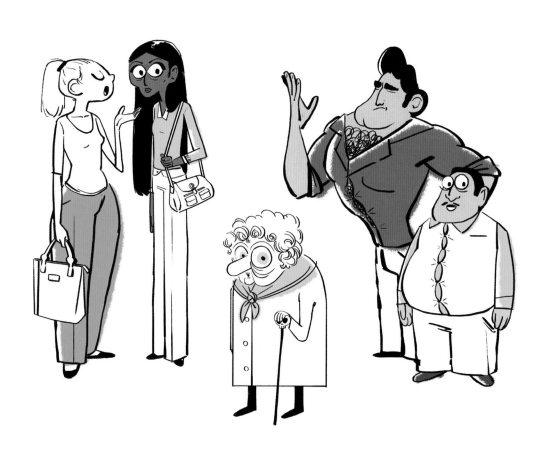

PREFACE

Give a kid their first set of crayons, and generally the thing they will want to draw is a human figure. But as we grow up, we may want to move on from that typical stick man image—adding more life and personality to our drawings, but without losing the spontaneity that can make every drawing a moment of pleasure. The secret is in learning to look: I love watching people—the way they stand, the kind of moves they make. And by looking, you start learning, too: how to position the various elements of a face, get the arms and legs moving in the right places, make the hands look "right," get the hair to look like hair. It's all essential stuff, and it's not magic! Soon enough, you will discover how to bend the rules of anatomy to create really dynamic characters that are full of personality. With just the right pose and facial expression, we can make our characters tell a whole story in one simple drawing. So now get set to start drawing your own stories—and say good-bye to the stick man!

Soizic Mouton

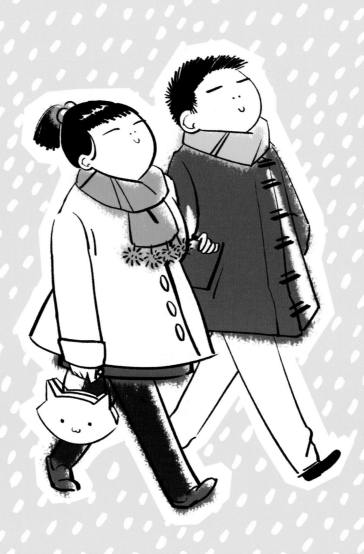

From
HEAD
to
TOE

What are we MADE OF?

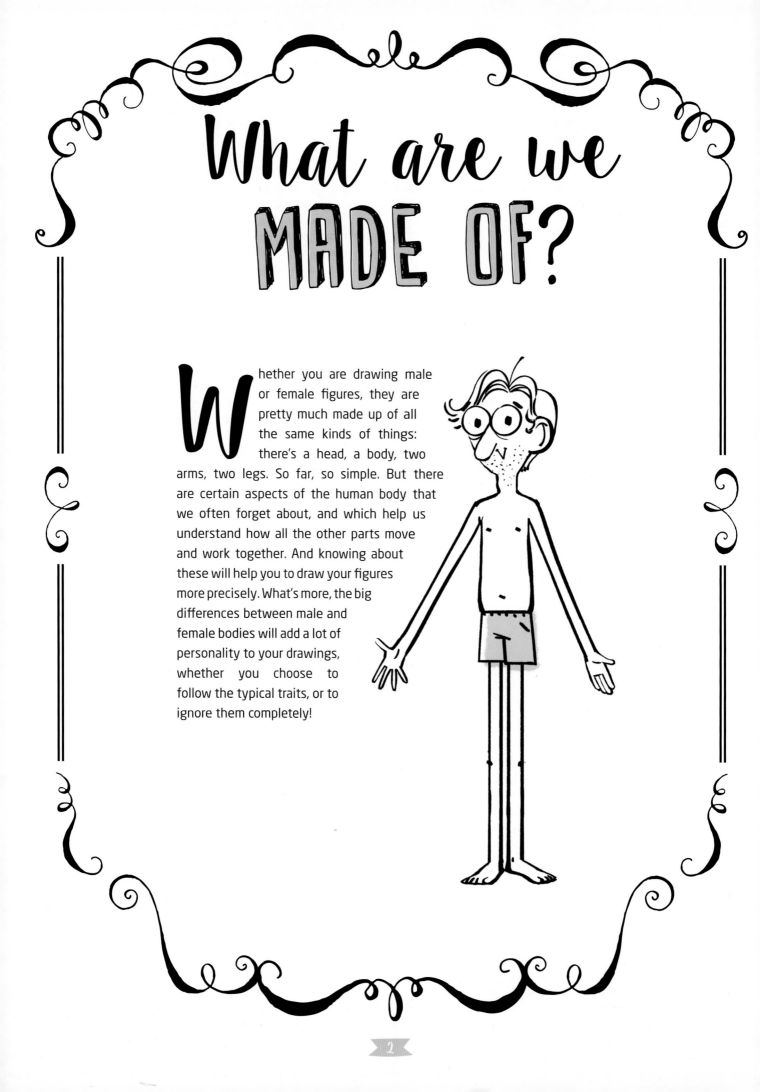

Whether you are drawing male or female figures, they are pretty much made up of all the same kinds of things: there's a head, a body, two arms, two legs. So far, so simple. But there are certain aspects of the human body that we often forget about, and which help us understand how all the other parts move and work together. And knowing about these will help you to draw your figures more precisely. What's more, the big differences between male and female bodies will add a lot of personality to your drawings, whether you choose to follow the typical traits, or to ignore them completely!

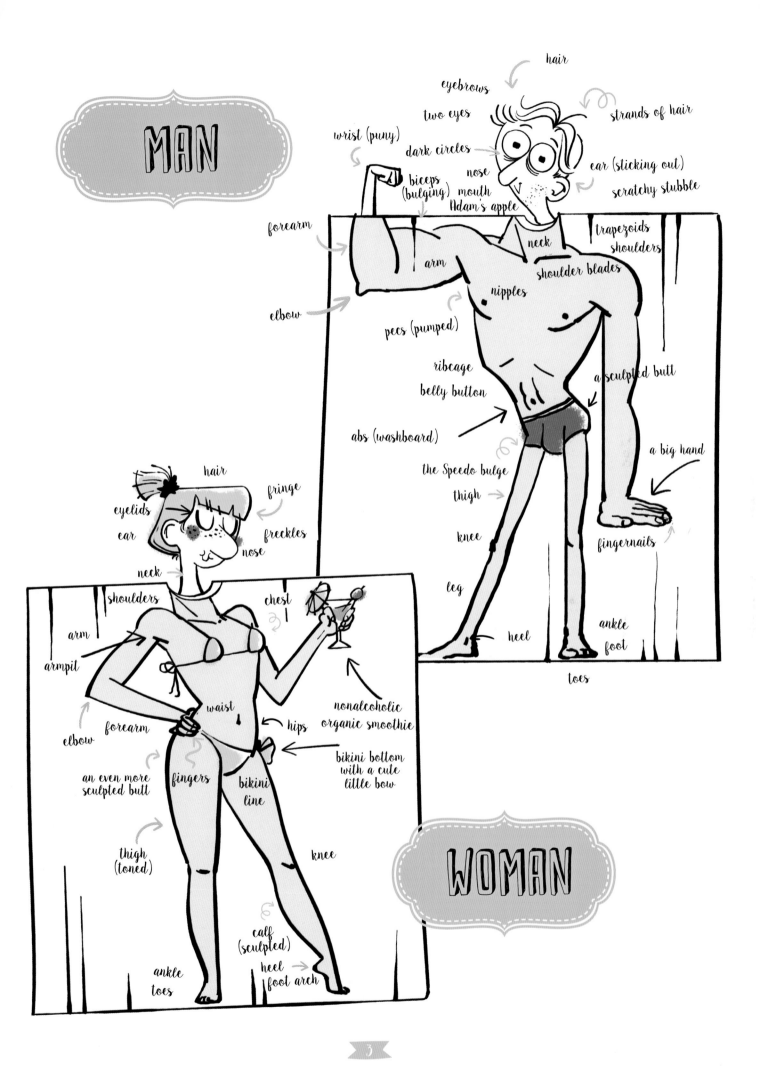

PROPORTIONS
and how to use them

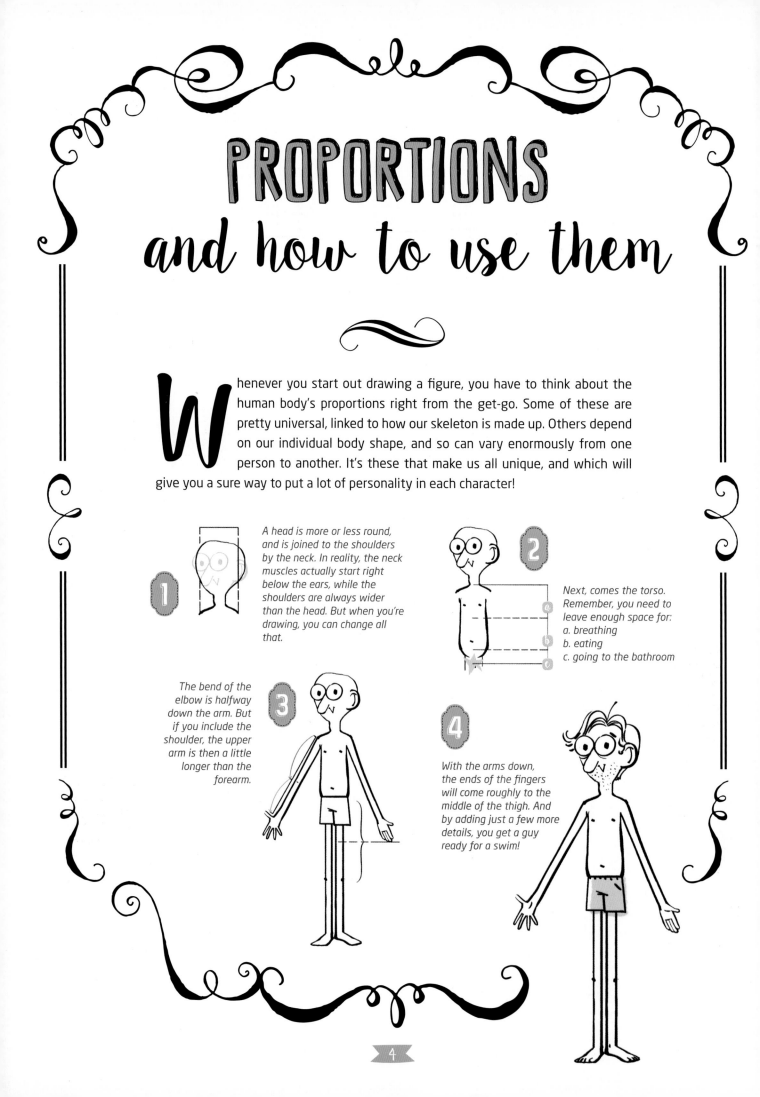

Whenever you start out drawing a figure, you have to think about the human body's proportions right from the get-go. Some of these are pretty universal, linked to how our skeleton is made up. Others depend on our individual body shape, and so can vary enormously from one person to another. It's these that make us all unique, and which will give you a sure way to put a lot of personality in each character!

1 A head is more or less round, and is joined to the shoulders by the neck. In reality, the neck muscles actually start right below the ears, while the shoulders are always wider than the head. But when you're drawing, you can change all that.

2 Next, comes the torso. Remember, you need to leave enough space for:
a. breathing
b. eating
c. going to the bathroom

3 The bend of the elbow is halfway down the arm. But if you include the shoulder, the upper arm is then a little longer than the forearm.

4 With the arms down, the ends of the fingers will come roughly to the middle of the thigh. And by adding just a few more details, you get a guy ready for a swim!

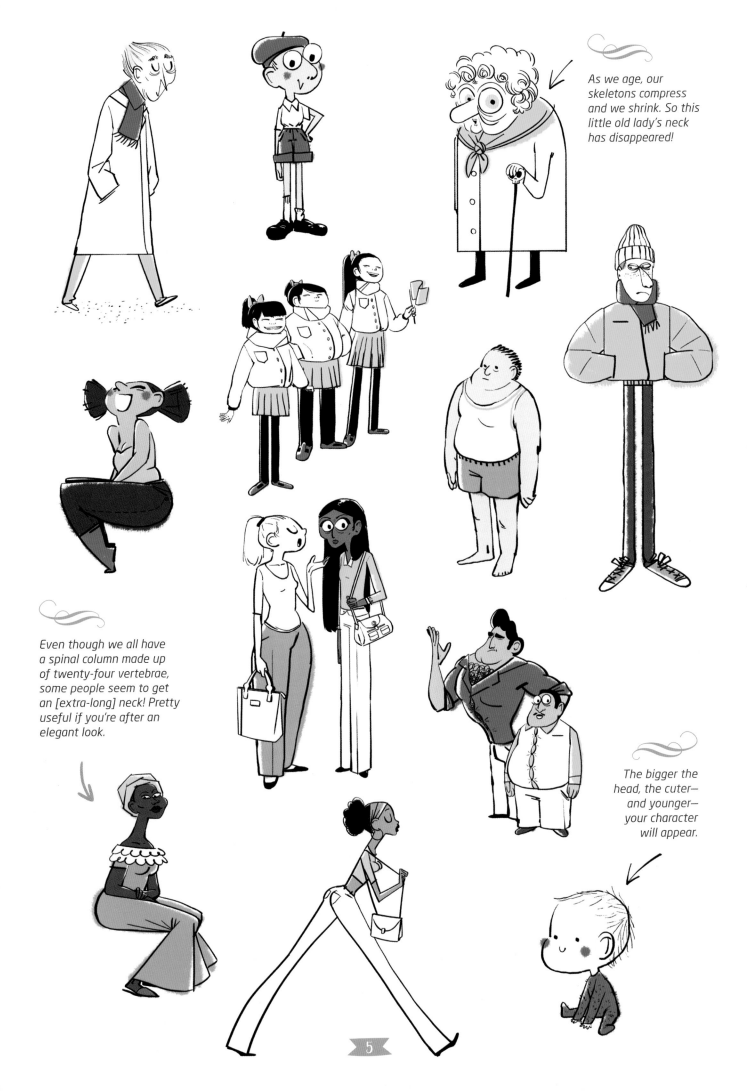

As we age, our skeletons compress and we shrink. So this little old lady's neck has disappeared!

Even though we all have a spinal column made up of twenty-four vertebrae, some people seem to get an [extra-long] neck! Pretty useful if you're after an elegant look.

The bigger the head, the cuter— and younger— your character will appear.

Five FINGERS, one billion hands

Aaagh! Hands are soooo scary! Yes, even for hardened professional artists, hands can give us all a big headache. So to help you draw them, here are some tips that someone once gave me: I still think about these every time I start drawing.

1 A hand is shaped a bit like a small shovel . . .

2 . . . onto which we add four fingers, roughly equally spaced, and a thumb on the side.

3 The little fold in the palm helps indicate which side of the hand is shown. And once you have chosen the position of the shovel part, the rest is easy!

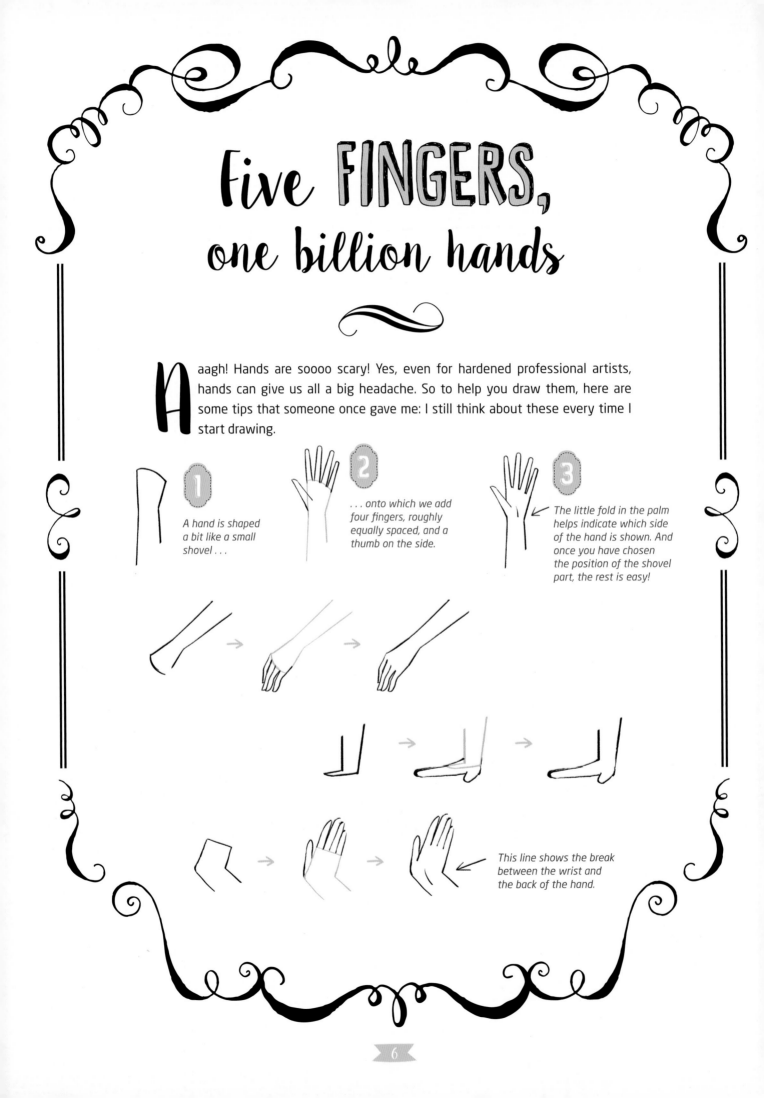

This line shows the break between the wrist and the back of the hand.

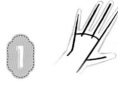

1 *Our fingers are rigid, thanks to the bones inside. And while fingers have amazing mobility, they won't move in every direction.*

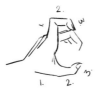

2 *Fingers can extend like this . . .*

3 *. . . and even like this!*

4 *Fingers will bend in three segments . . .*

5 *. . . but we can't twist them around like noodles.*

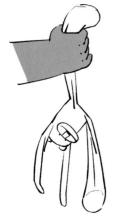

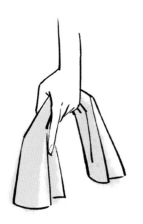

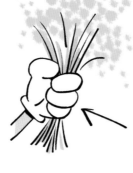

This hand is really bendy!

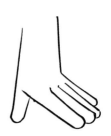

You think five fingers are just too many to draw? Then take one away!

You would not be the first artist to do this . . .

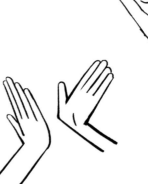

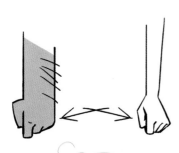

Some drawing styles allow you to use a kind of graphic shortcut. The position of the hand is clear, but with way fewer details.

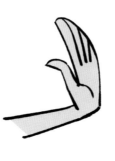

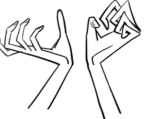

Your FEET don't look like bread rolls

Hands are certainly hard to draw, but feet can be just as tricky! Compared with other parts of the body, the shape of a foot is often hard to figure out, which does not make things any easier. Take a look at how a foot is made up . . . and if you don't get the result you were hoping for, draw on some shoes: they solve the problem, and are great fun to draw!

1

From the side, you can "build" a foot from a triangle that roughly shows the bone structure inside the foot.

2

This triangle helps us to think about a foot in different positions.

3

Seen from the back, you'll notice that the anklebone on the outside of your foot is higher up than the one on the inside. And what's in between them? The Achilles tendon!

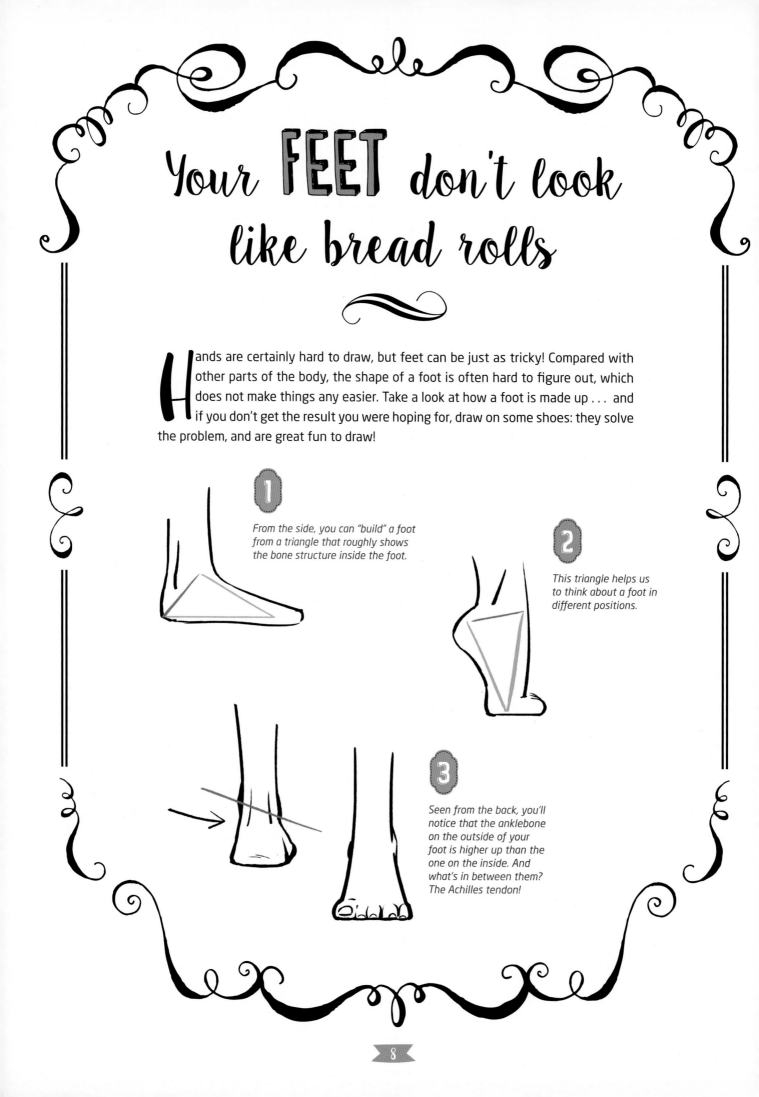

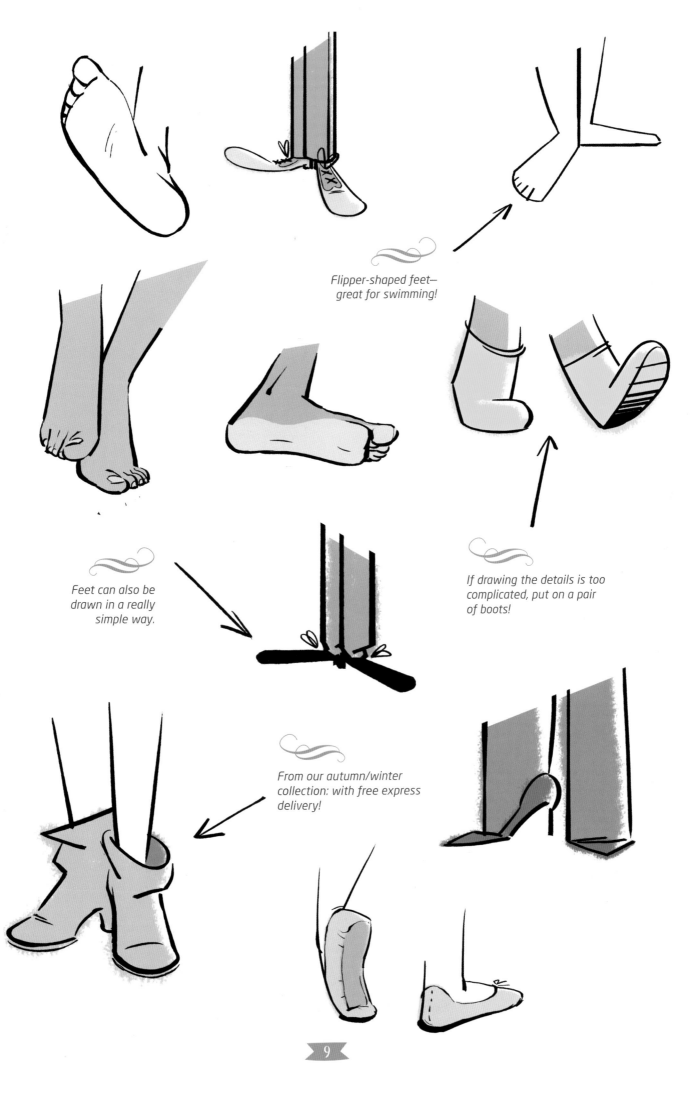

*Flipper-shaped feet—
great for swimming!*

*Feet can also be
drawn in a really
simple way.*

*If drawing the details is too
complicated, put on a pair
of boots!*

*From our autumn/winter
collection: with free express
delivery!*

Get some HEAD space!

As the head is connected directly to the skeleton, its movement is subject to some pretty strict rules that are worth keeping in mind when drawing a figure. But the head is also made up of a whole bunch of parts that vary enormously from one person to another—and that provide a lot of the fun when you're drawing. You can combine all these individual traits in an infinite number of ways to create figures bursting with character.

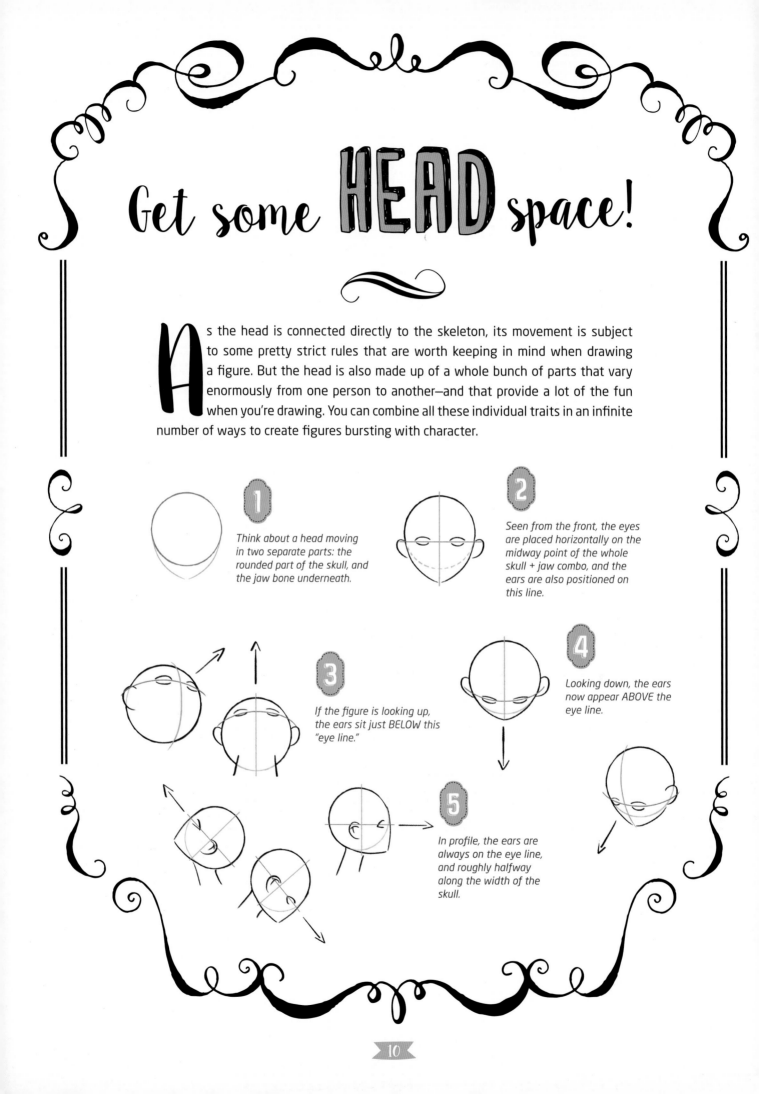

1
Think about a head moving in two separate parts: the rounded part of the skull, and the jaw bone underneath.

2
Seen from the front, the eyes are placed horizontally on the midway point of the whole skull + jaw combo, and the ears are also positioned on this line.

3
If the figure is looking up, the ears sit just BELOW this "eye line."

4
Looking down, the ears now appear ABOVE the eye line.

5
In profile, the ears are always on the eye line, and roughly halfway along the width of the skull.

Enlarging the eyes gives a look that is sometimes mischievous, and sometimes severe.

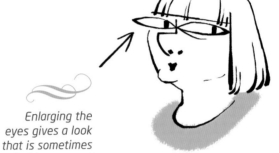

Seen from the back, if the ears are not sticking out, they look a bit like a small frankfurter.

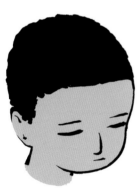

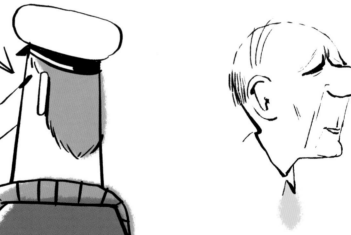

You can even draw heads that are not round at all!

Taking care of the HAIR

Hair is not really like a single thing with a shape. It's actually billions of little things with shapes—the individual strands, one next to the other. Also, it is best to avoid trying to draw hair as if it has been gathered together in a bag. It can make the drawing look heavy, and sometimes, it's hard to work out what this bag-shaped thing actually is!

By drawing just a few small hairs—and even leaving gaps—we can see straight away what we're looking at, and the drawing has a lot more spark.

. . . even if it's growing in every direction!

Draw hair in the direction that it grows, from the roots to the ends . . .

Feel free to change your pen, marker, or brush, to get the effect you're looking for.

Drawing a back view of someone's hair, without any kind of outline, is a lot of fun. Try it and you'll see. You could even draw a whole family of heads viewed from behind, starting with nothing more than a set of your own fingerprints!

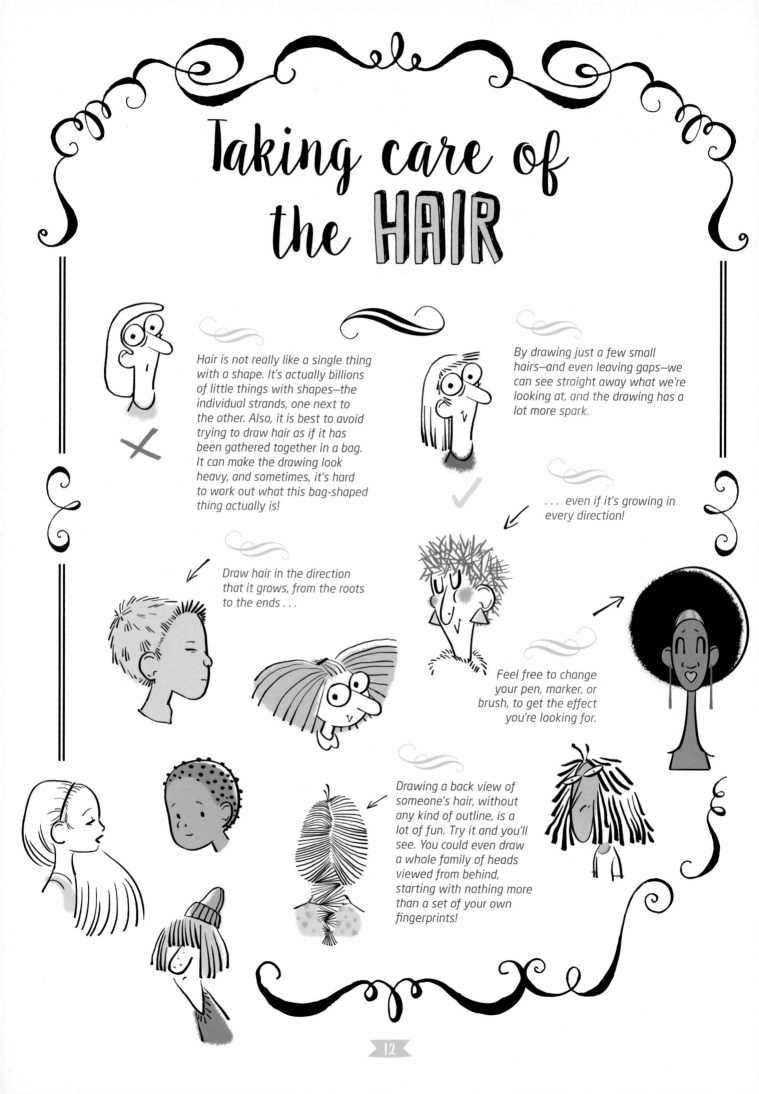

Speak with the EYES
—and the MOUTH

The various elements of a face (the eyes, mouth, and the nose) vary enormously from one person to another. You will still need to think about the rules of anatomy, but the real fun comes when you start to play around and draw whatever comes into your head!

 We saw earlier that the eyes are roughly in the middle of the face, and line up with the top of the ears.

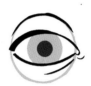

 The eyeball does not grow during the course of our lives—it stays the same size from birth. This is why babies appear to have such big eyes. There is an eyelid above and below the eyeball to protect it—though only the top one moves, allowing us to shut our eyes.

 From the side, we can see the fold of the eyelid. The eyelashes are like two small brushes that protect the eye from dust.

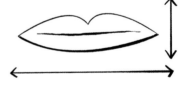

 The mouth is made up of soft tissue, and varies in width and thickness from one person to another. So you can draw it however you want!

 From the side, the mouth looks a bit like a little heart on its side.

 Remember not to forget the chin. The jawbone is pretty big, and you need to leave it some space.

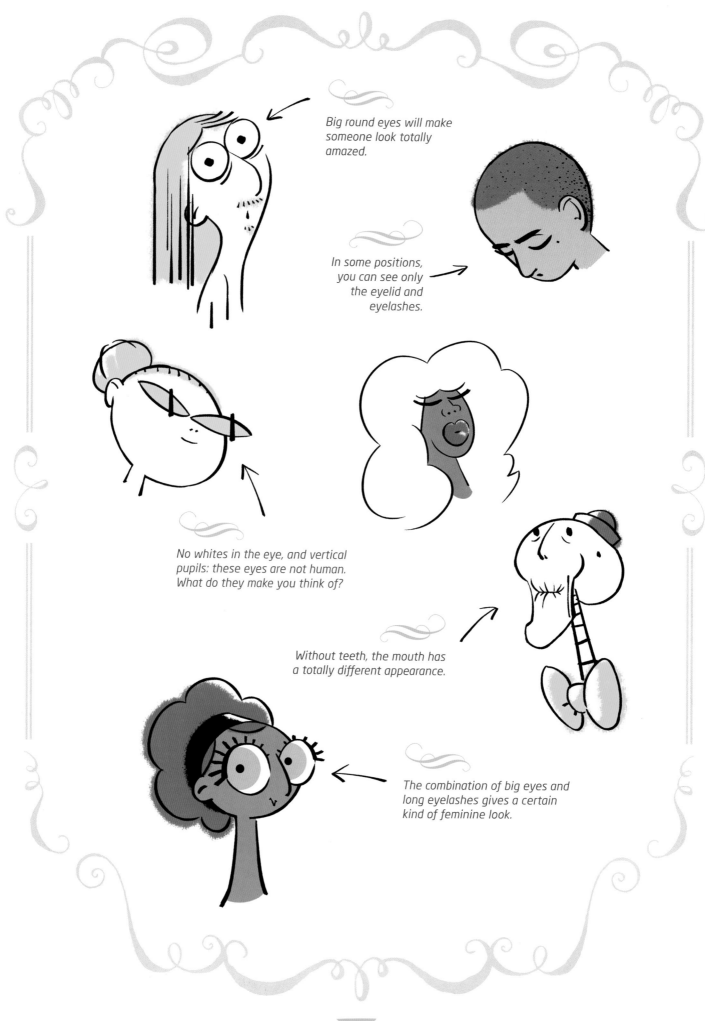

Big round eyes will make someone look totally amazed.

In some positions, you can see only the eyelid and eyelashes.

No whites in the eye, and vertical pupils: these eyes are not human. What do they make you think of?

Without teeth, the mouth has a totally different appearance.

The combination of big eyes and long eyelashes gives a certain kind of feminine look.

Where the NOSE goes

The nose is usually the most prominent part of the face.
But you don't get to see all of it at once.

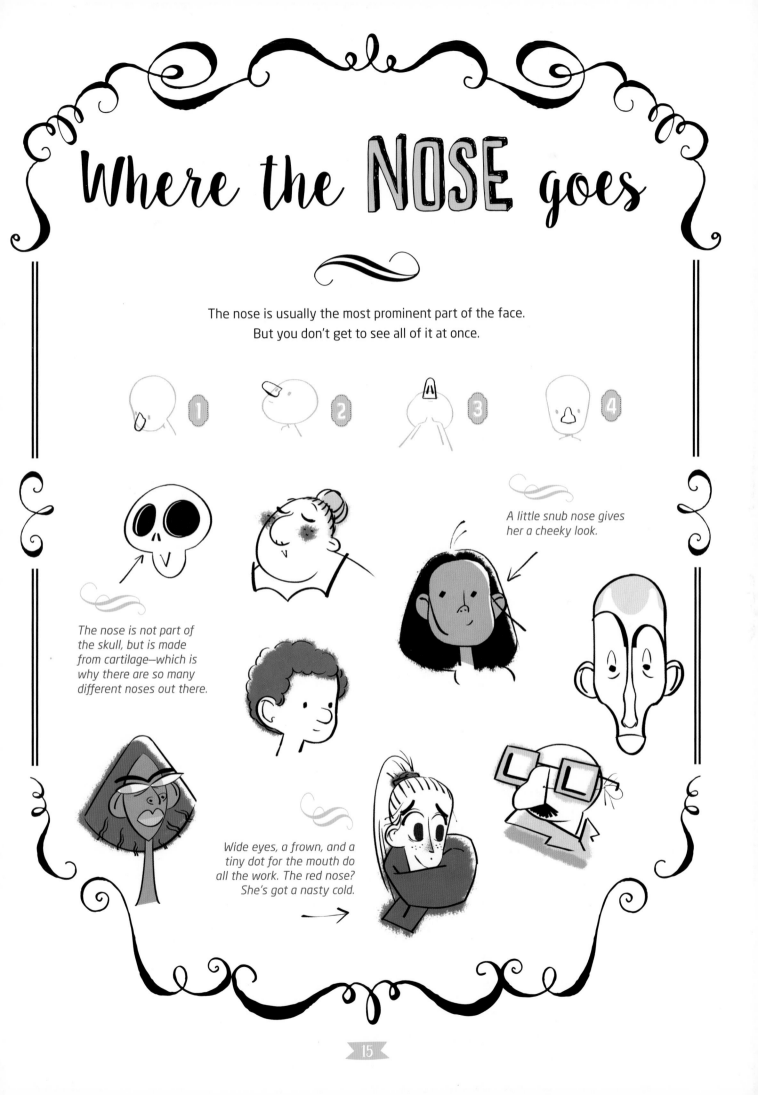

The nose is not part of the skull, but is made from cartilage—which is why there are so many different noses out there.

A little snub nose gives her a cheeky look.

Wide eyes, a frown, and a tiny dot for the mouth do all the work. The red nose? She's got a nasty cold.

HAPPY ... or not HAPPY?

When you draw a character, you're right away telling a story. But to make that story come alive, your character needs personality. The human face is very mobile, and can show an infinite number of subtle expressions that can be fascinating to watch. To get these into your drawing, you need to be ready to exaggerate, big time. Animated cartoons, comic books, manga, and even emojis all use a kind of graphic shorthand of faces, gestures, and expressions, which our brains know immediately how to interpret. Use them for inspiration. And when it comes to expressing an emotion, remember that the eyes are absolutely crucial. So are the eyebrows, even though we often forget to use them: they can really emphasize the look on a face. And finally, don't forget that the whole body can also take part in expressing our emotions.

Amused

Tranquil

Happy

Suspicious

Sad

Whatever

Doubtful

Fearful

Despairing

Embarrassed

Irritated

Enraged

Soooo Happy

Neutral

17

HAPPY ...
or (still) not HAPPY?

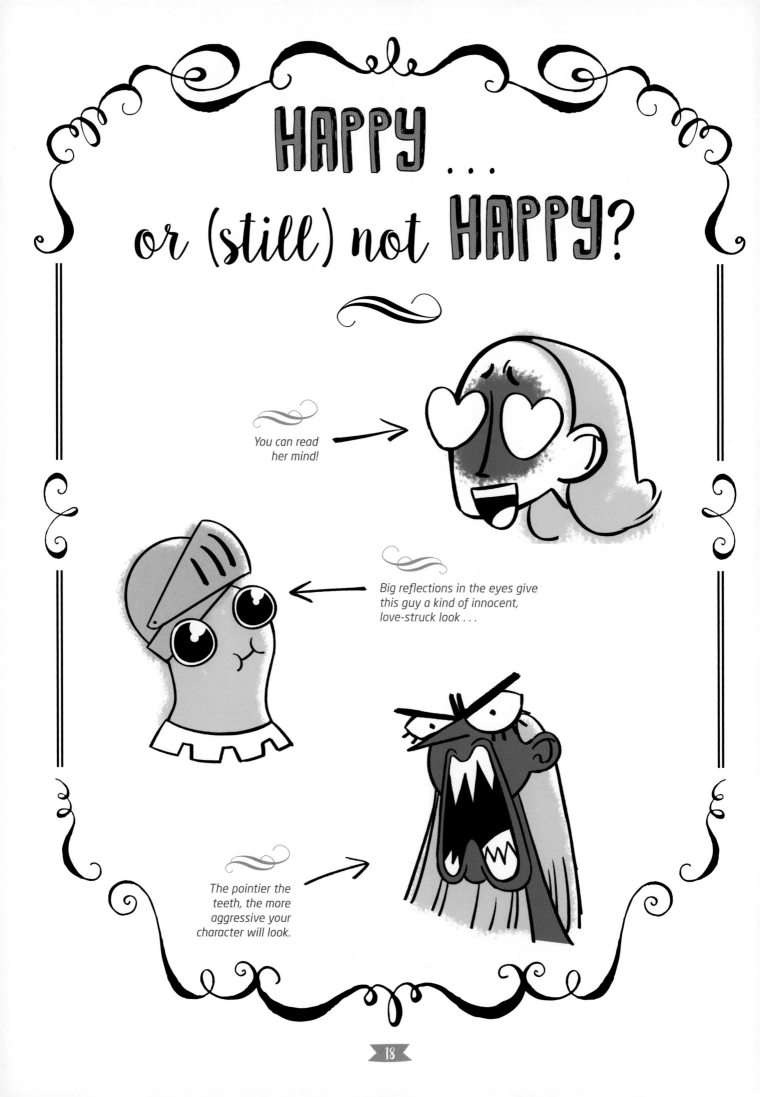

You can read her mind!

Big reflections in the eyes give this guy a kind of innocent, love-struck look . . .

The pointier the teeth, the more aggressive your character will look.

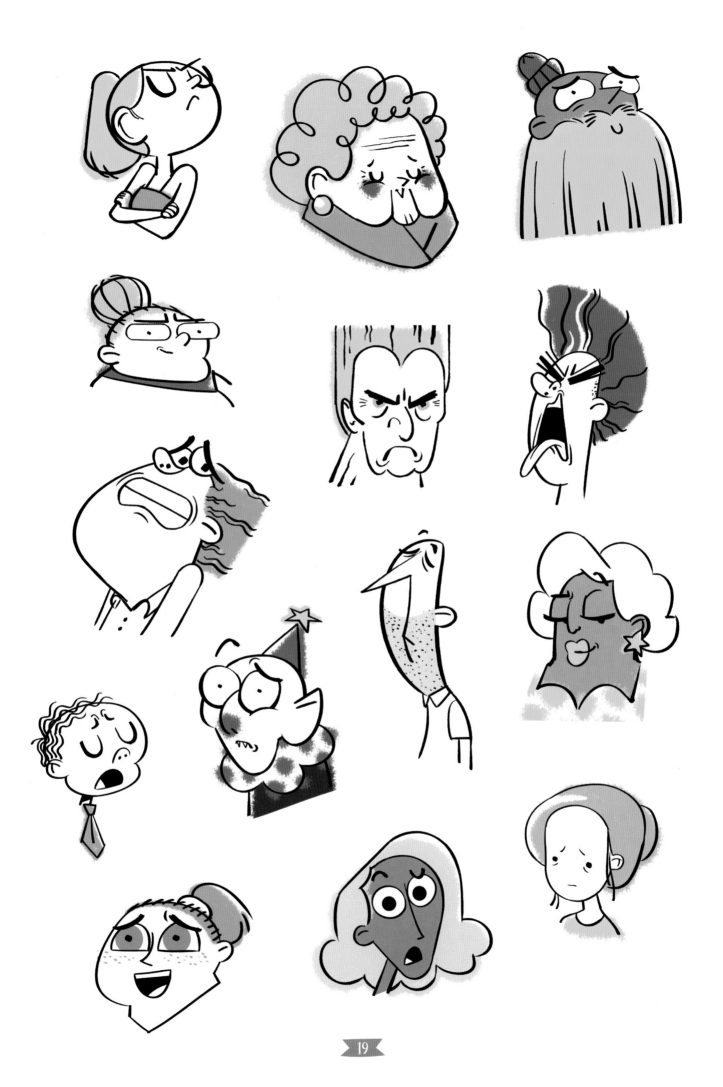

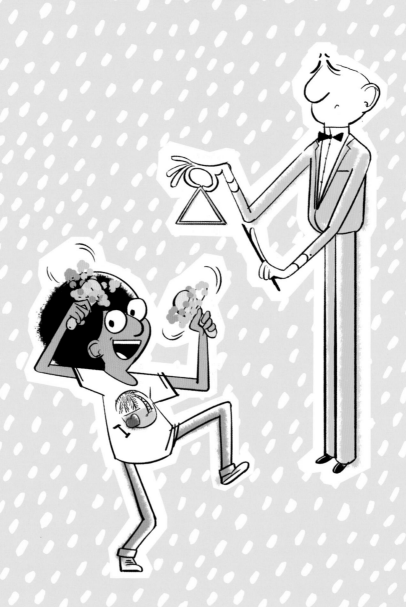

Bring your CHARACTER to LIFE!

In the BATHROOM

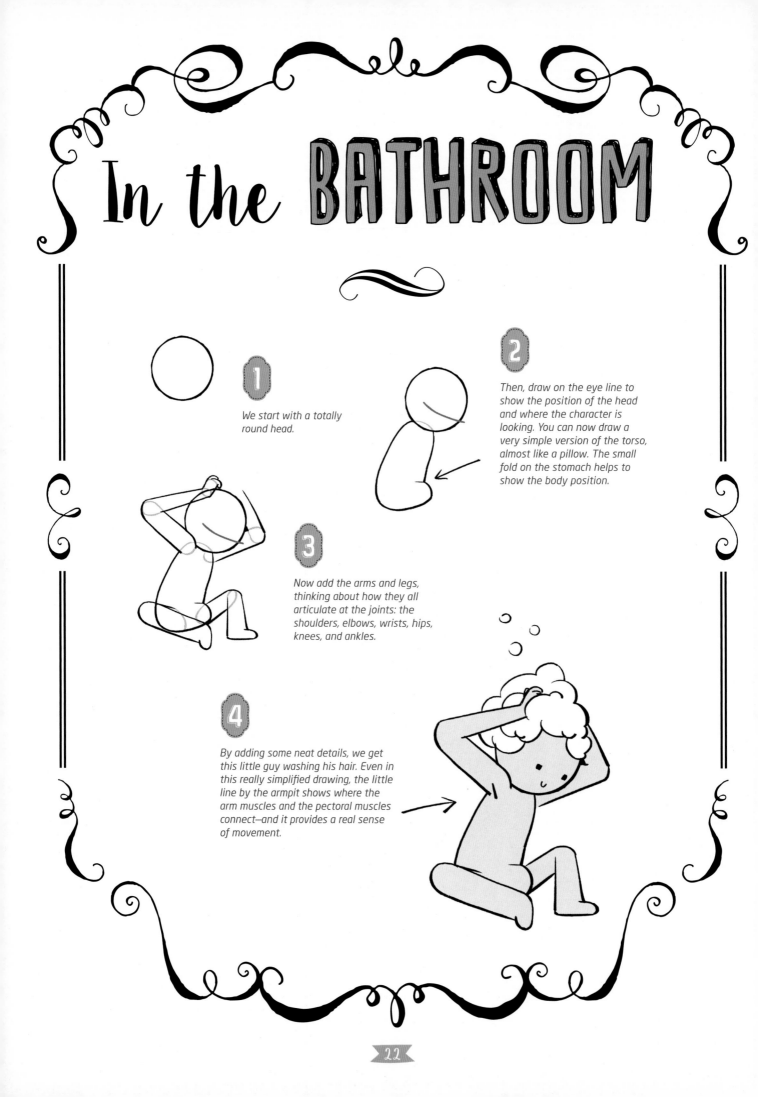

1

We start with a totally round head.

2

Then, draw on the eye line to show the position of the head and where the character is looking. You can now draw a very simple version of the torso, almost like a pillow. The small fold on the stomach helps to show the body position.

3

Now add the arms and legs, thinking about how they all articulate at the joints: the shoulders, elbows, wrists, hips, knees, and ankles.

4

By adding some neat details, we get this little guy washing his hair. Even in this really simplified drawing, the little line by the armpit shows where the arm muscles and the pectoral muscles connect—and it provides a real sense of movement.

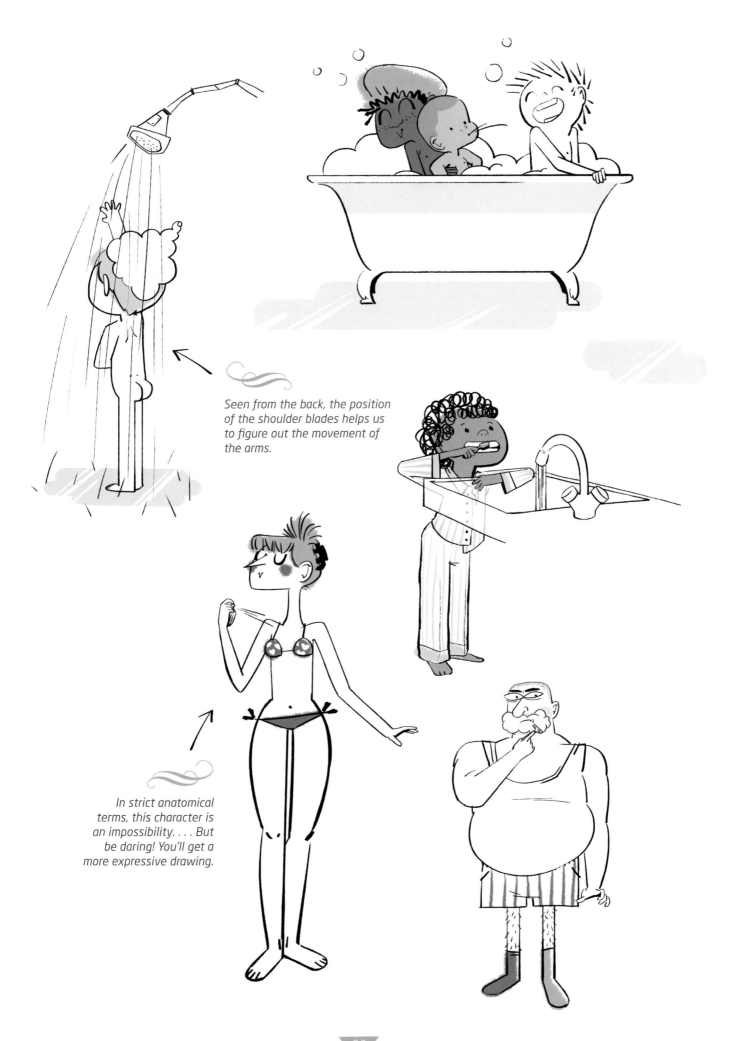

Seen from the back, the position of the shoulder blades helps us to figure out the movement of the arms.

In strict anatomical terms, this character is an impossibility. . . . But be daring! You'll get a more expressive drawing.

23

Getting DRESSED

1

You start with the head, more or less round.

2

Add the eye line, and then the torso and the neck to join it to the head.

3

As well as the eye line, the position of the ears and nose help to show which way the character is looking. Add the arms and legs, thinking about the joints and how they articulate. If you want to keep this simple and make the drawing easy to understand, you can leave out the (hidden) left arm completely.

4

Put in a few more details, you can get your character to put on whatever you like!

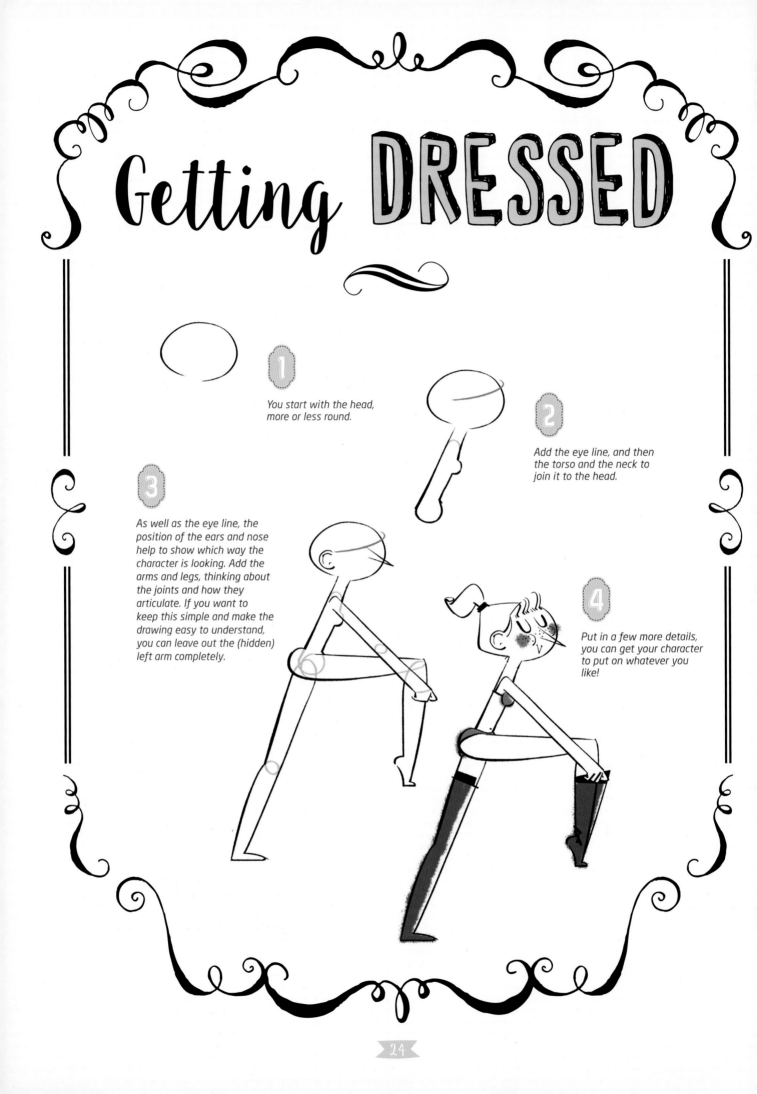

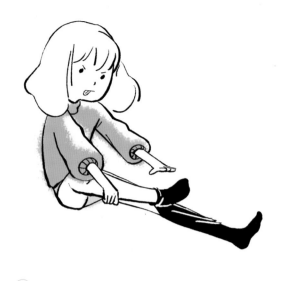

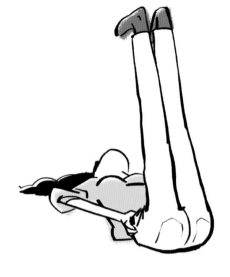

Struggling with a sweater: an instant comedy moment.

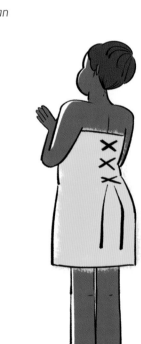

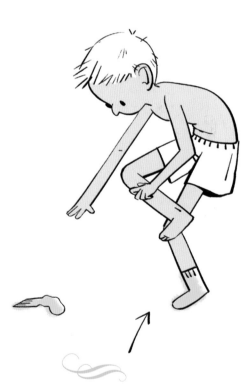

The essential part of this drawing (the sock on the ground) is placed way to the left of the boy's center of balance—which adds a huge amount of dynamism.

Going PLACES

1

Start with the head, remembering to include both the skull and the jawbone.

2

Then, draw in the eye line, with the eyes looking straight ahead (safer for cycling . . .). What comes next is the upper body and the neck. Remember that on a bike, your back is not vertical, but is leaning forward. From this point, you can now draw a bike for the person to sit on—and you may want to use a compass and ruler to make the bike really neat.

3

Now you can draw in the limbs. As the rider is leaning forward, the arms are rigid as they carry the weight of the upper body. The wrists point to the ground. It doesn't matter if you draw the foot or the pedal first—as one automatically follows the other.

4

With a few extra details, we now have a young guy who is environmentally friendly, likes to keep fit, and takes good care of his pet.

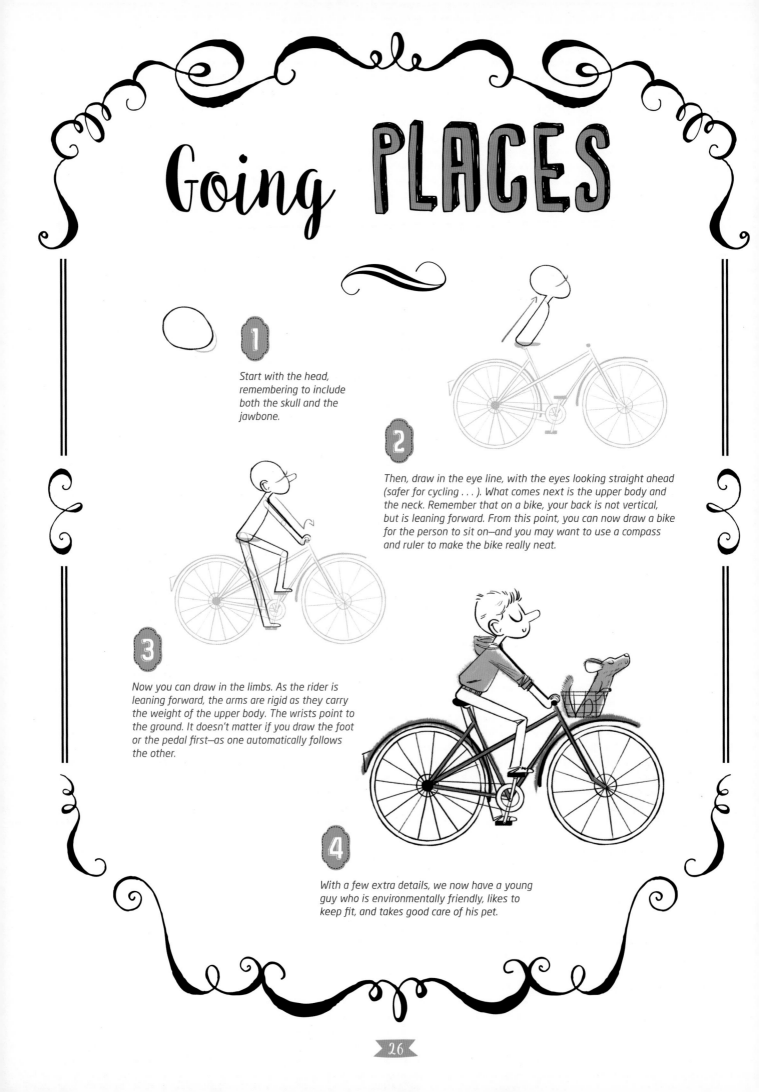

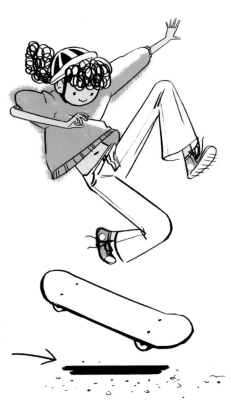

 Small details in clothes and hair can help show the effects of the wind and give a great sense of speed and movement.

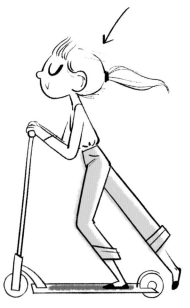

 Putting a shadow underneath an object—but without touching it—makes the object look like it is suspended in midair.

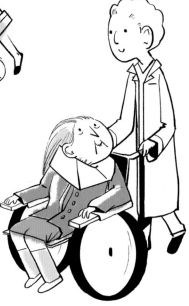

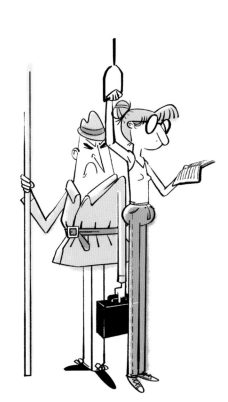

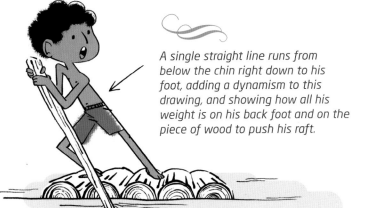

A single straight line runs from below the chin right down to his foot, adding a dynamism to this drawing, and showing how all his weight is on his back foot and on the piece of wood to push his raft.

MESSING about!

1

We start with a round head.

2

Next, the eye line, and a really small body. There's no neck: The head here is so out of proportion that we don't even see the neck.

3

Now we add the arms and legs. We tend to forget this, but the arms play a big role when we get our bodies to jump. Here, the shoulders are up, and the right shoulder is actually in front of the face.

4

Add in a few final details, and you'll remember what fun it is to jump up in the air!

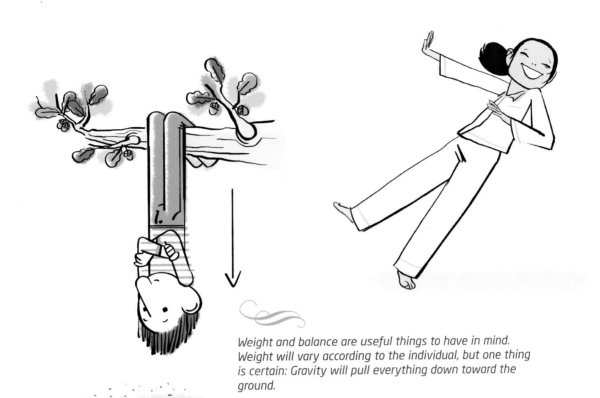

Weight and balance are useful things to have in mind. Weight will vary according to the individual, but one thing is certain: Gravity will pull everything down toward the ground.

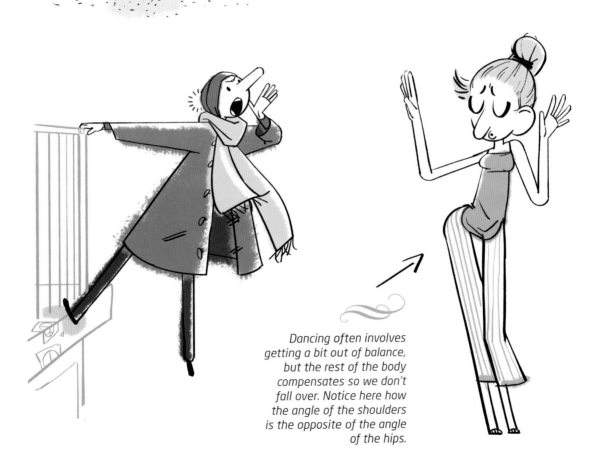

Dancing often involves getting a bit out of balance, but the rest of the body compensates so we don't fall over. Notice here how the angle of the shoulders is the opposite of the angle of the hips.

Going to WORK

1

Start with the head—remembering the jawbone.

2

After putting in the eye line, draw the body in the style of a snowman: a ball for the head, one for the upper body, a bigger one for the middle of the torso, and add a kind of skirt area for the lower part.

3

Now add the limbs and the various objects she will hold. Remember: The legs, even though tiny, must line up with the middle of the body. They can't just stick out under the skirt any old where!

4

With a few extra details, I now have a portrait of the check-out lady at my local supermarket.

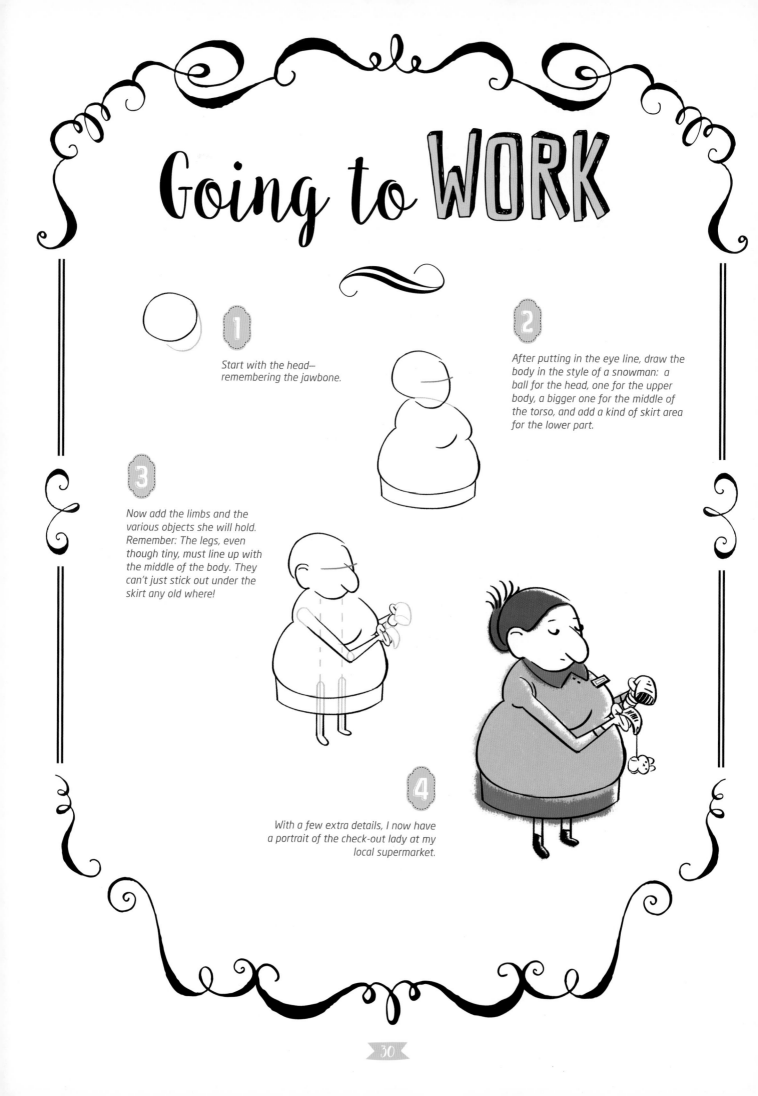

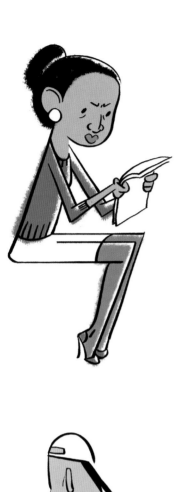

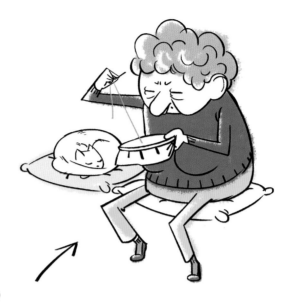

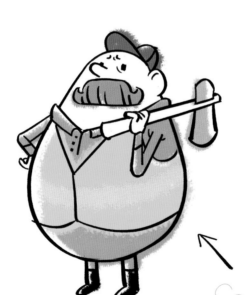

Some people work sitting down, others standing up. In most cases, we hardly change position during the whole day. Ouch! My back! Right now, take a look at yourself: What position best captures your own working style?

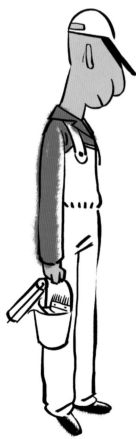

Some kinds of work are characterized by the clothes and gear that are essential to carrying it out.

Too much WORK!

Now let's try a drawing that's more spontaneous, without the building blocks. The key thing is to keep in mind the character's own attitude or mood as you draw. Here, he is really angry and shouting, and leaning forward to make his voice even louder. The general direction of the body shape is forward, and upward.

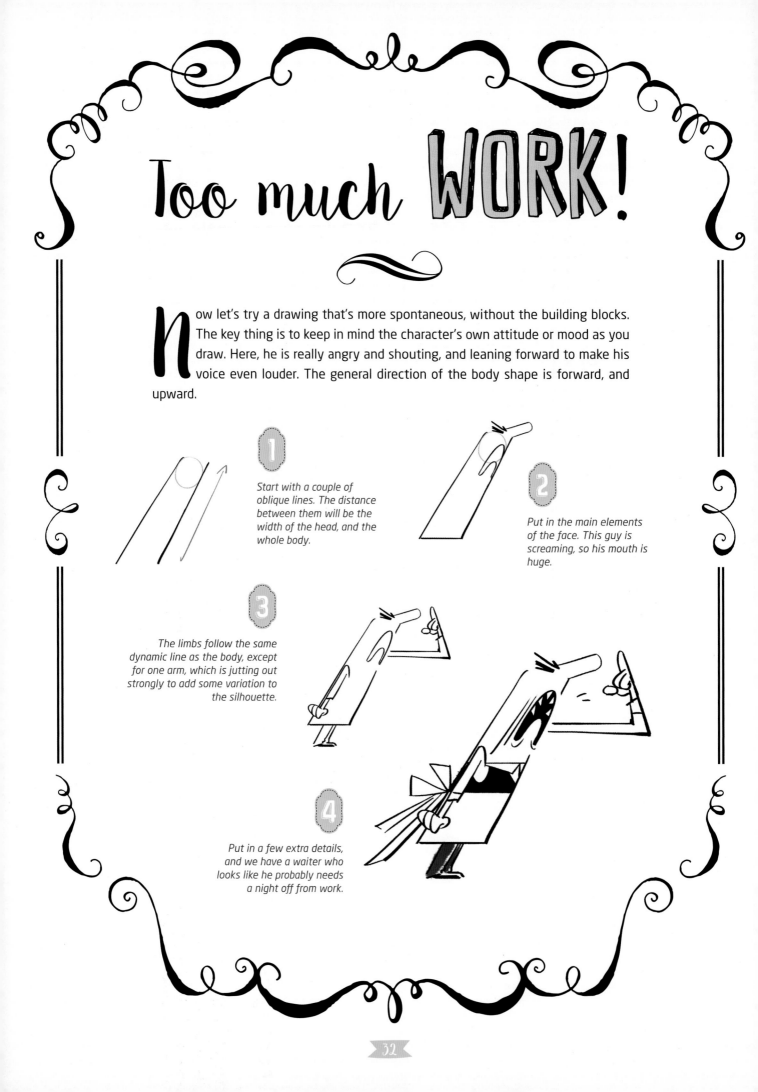

1

Start with a couple of oblique lines. The distance between them will be the width of the head, and the whole body.

2

Put in the main elements of the face. This guy is screaming, so his mouth is huge.

3

The limbs follow the same dynamic line as the body, except for one arm, which is jutting out strongly to add some variation to the silhouette.

4

Put in a few extra details, and we have a waiter who looks like he probably needs a night off from work.

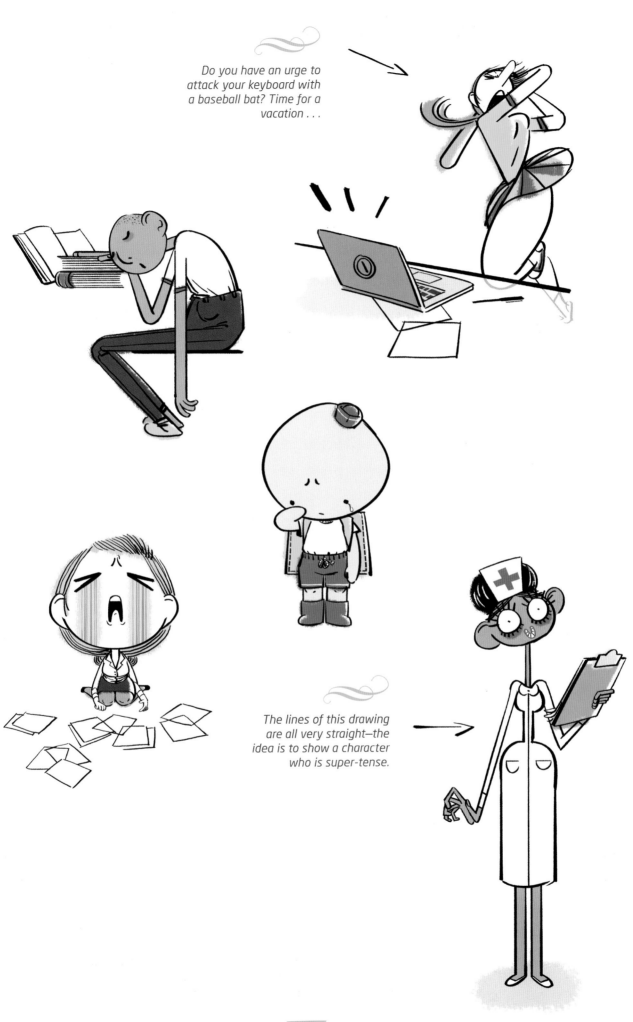

Do you have an urge to attack your keyboard with a baseball bat? Time for a vacation . . .

The lines of this drawing are all very straight—the idea is to show a character who is super-tense.

Get COOKING

1

Start with a completely round head.

2

Draw the eye line toward the top of the head, so she is ready to catch the pancake. Then comes the upper body and the neck. The back is slightly rounded, and the character is bent over a little for extra stability.

3

To draw in the limbs, start with the feet, placed equidistant from a center line that drops down from between the shoulders.

4

A few details more, and here is someone ready for breakfast (just need to perfect catching that pancake)!

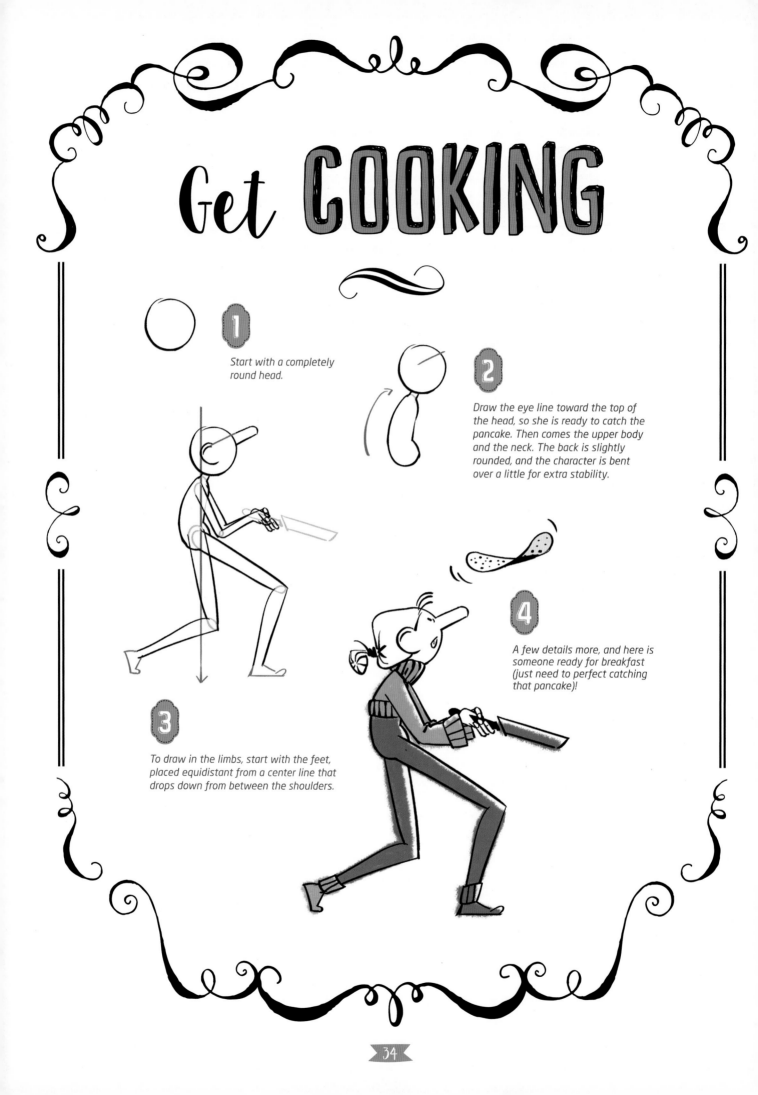

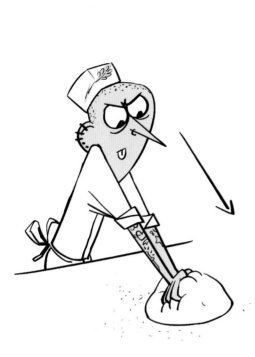

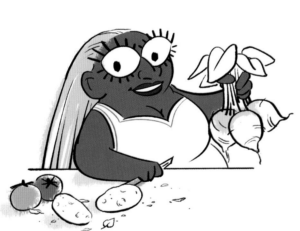

With his arms straight and rigid, the baker is putting all his energy into kneading the dough.

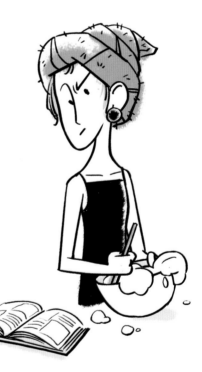

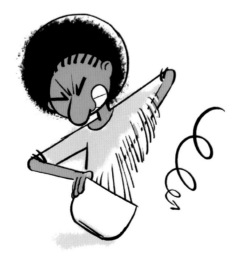

Whoa! Her arm is turning so fast we can't even see it!

Time for a WORKOUT

1 Start with the head—including the lower jaw.

2 Next, comes the torso and the neck. As with walking, running actually involves being in a constant state of toppling forward. So the torso is pitched forward to give the impression of movement.

3 Then draw in the limbs, which move a bit like the parts of a puppet: The forward arm and the forward leg are on opposite sides. It looks even more dynamic with a really straight front leg.

4 You can add in whatever details you like. If it looks good, run with it!

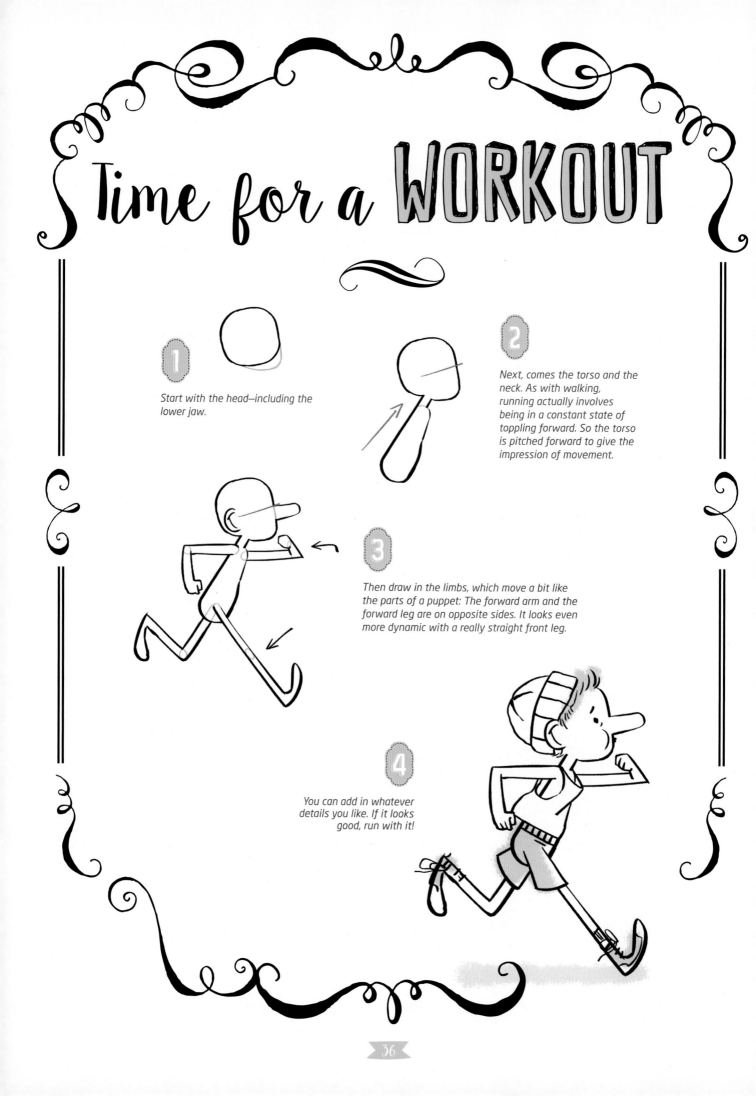

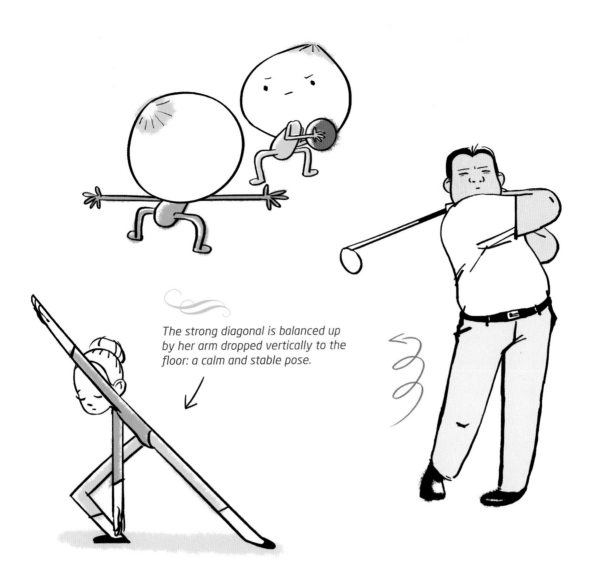

The strong diagonal is balanced up by her arm dropped vertically to the floor: a calm and stable pose.

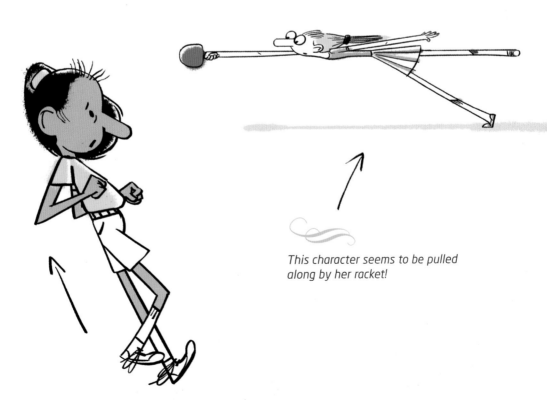

This character seems to be pulled along by her racket!

Going to SLEEP

1
Get started with a really round head.

2
Draw in the eye line, and a line for the center of the nose to show which way the head is looking.

3
Next, we draw the body, and then the neck, which has almost disappeared underneath the head, and finally the limbs. Disconnecting the movement of the arms and legs makes the body look supple and relaxed, which is also why the head is off to one side.

4
Finally, put on some pajamas, and time for a snooze!

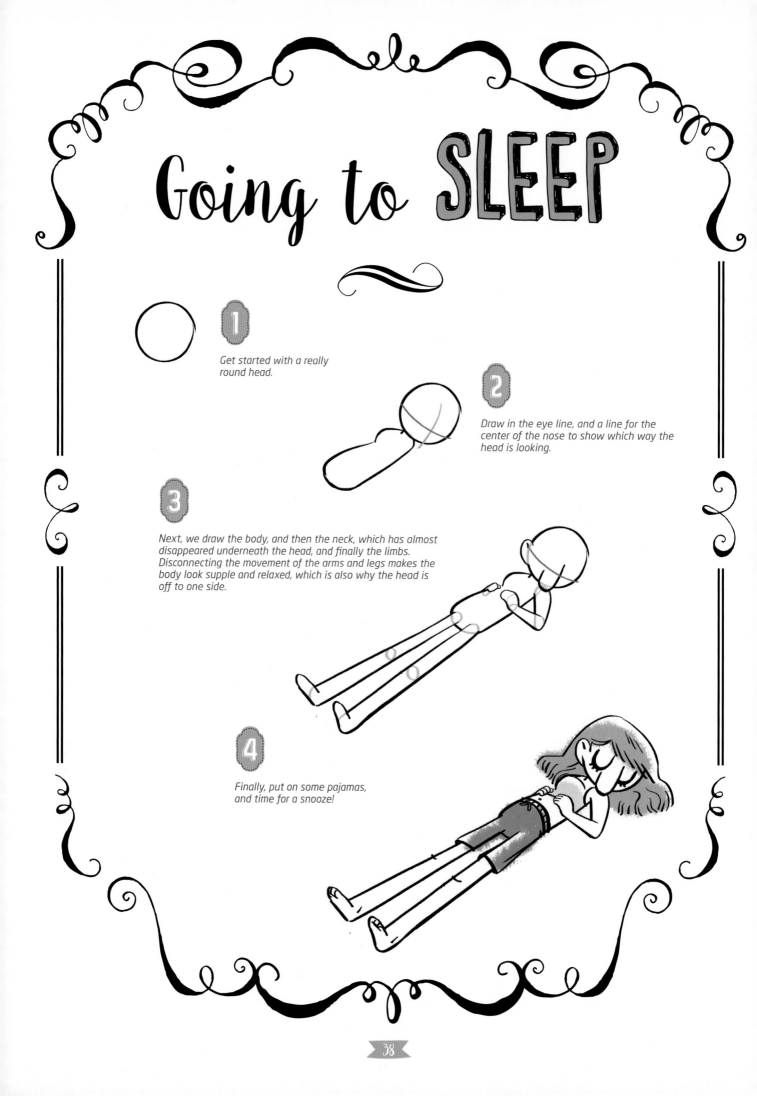

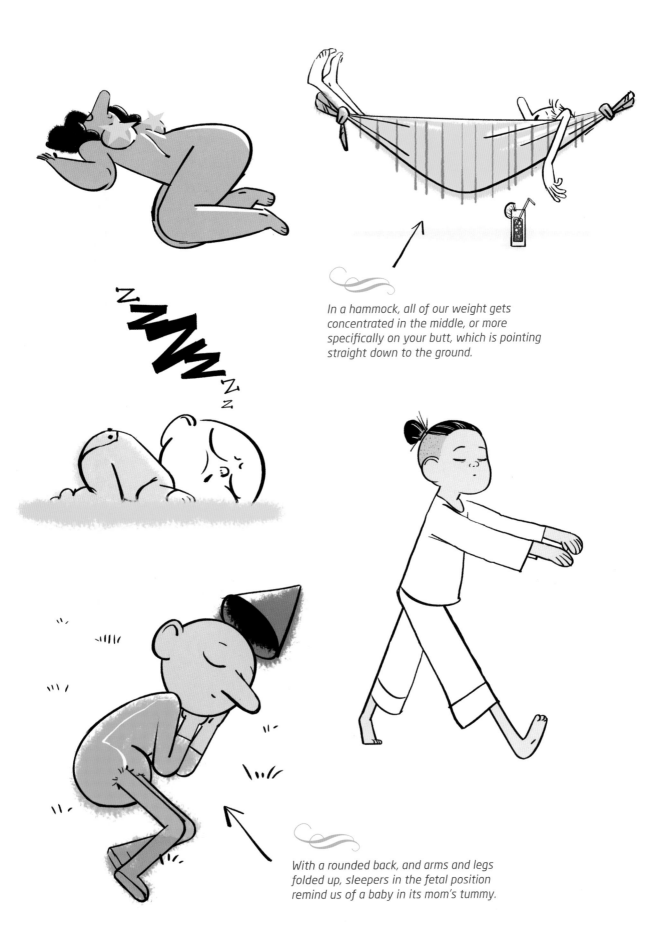

In a hammock, all of our weight gets concentrated in the middle, or more specifically on your butt, which is pointing straight down to the ground.

With a rounded back, and arms and legs folded up, sleepers in the fetal position remind us of a baby in its mom's tummy.

LEISURE *pleasure*

1

Start by drawing the head, including the lower jaw. This time, our character will have a longish head rather than a round one.

2

Next, draw in the eye line, the body, and the neck. Once you have drawn in the length of the upper body, you can draw in the armchair behind. Even only partially drawn, the figure needs to look seated in the chair.

3

Now come the limbs, arms, and legs, positioned to adapt to the design of the chair you have chosen. But start off drawing the book: the distance between the reader and the book is going to determine the sitting position and the general posture of your character. The feet don't necessarily need to touch the ground. The more the character looks small in relation to the chair, the more they will look young, or will have a kind of Alice in Wonderland vibe.

4

Now just add a few more details, and settle in for a good read!

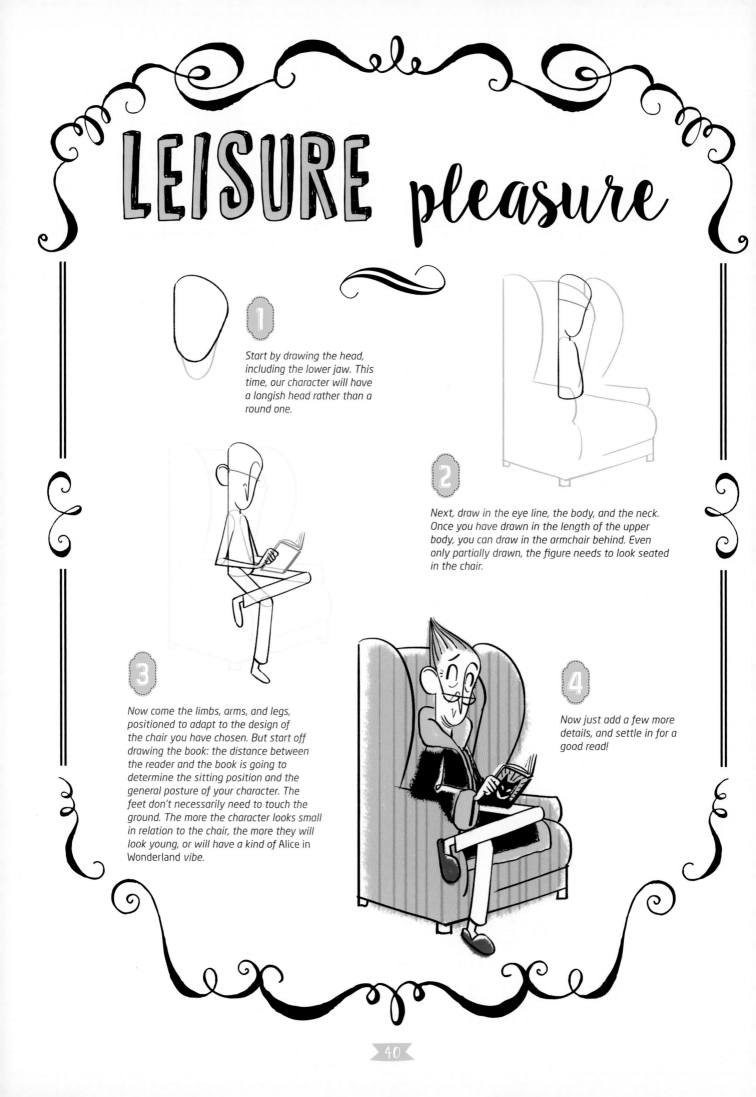

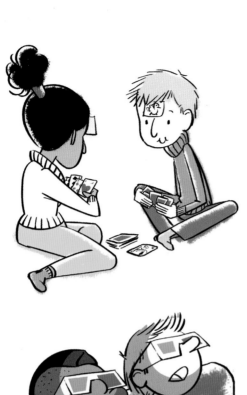

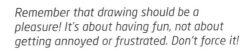

Remember that drawing should be a pleasure! It's about having fun, not about getting annoyed or frustrated. Don't force it!

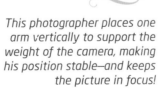

This photographer places one arm vertically to support the weight of the camera, making his position stable—and keeps the picture in focus!

House WORK

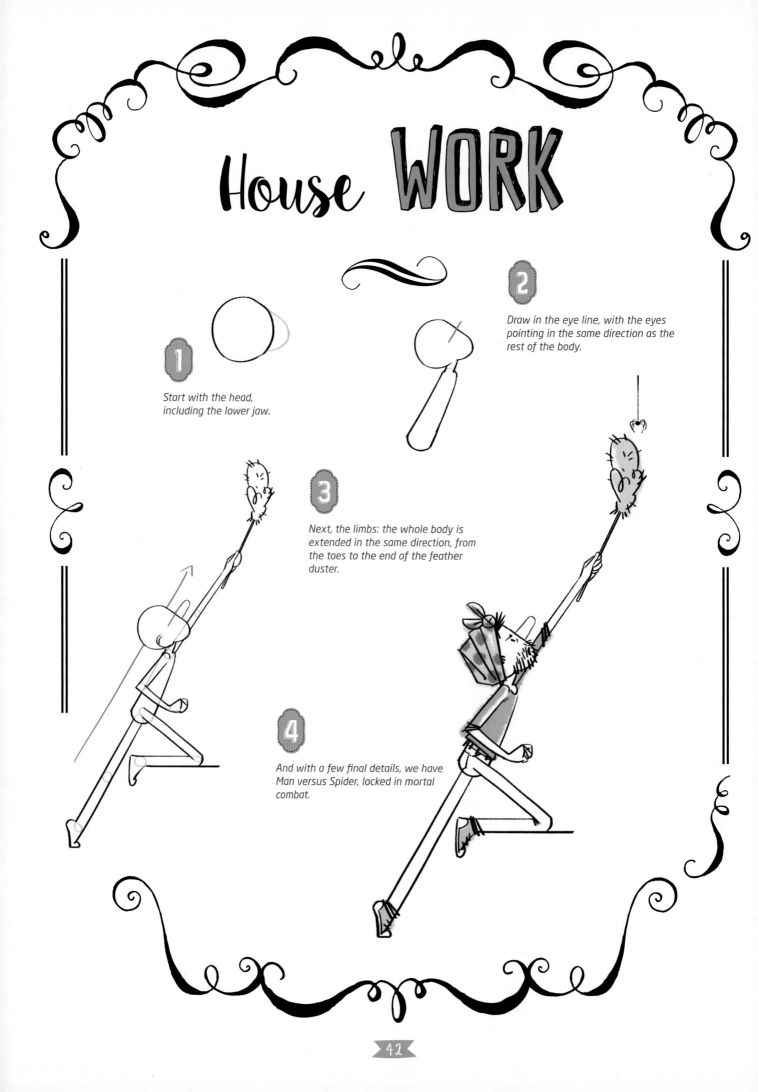

1 Start with the head, including the lower jaw.

2 Draw in the eye line, with the eyes pointing in the same direction as the rest of the body.

3 Next, the limbs: the whole body is extended in the same direction, from the toes to the end of the feather duster.

4 And with a few final details, we have Man versus Spider, locked in mortal combat.

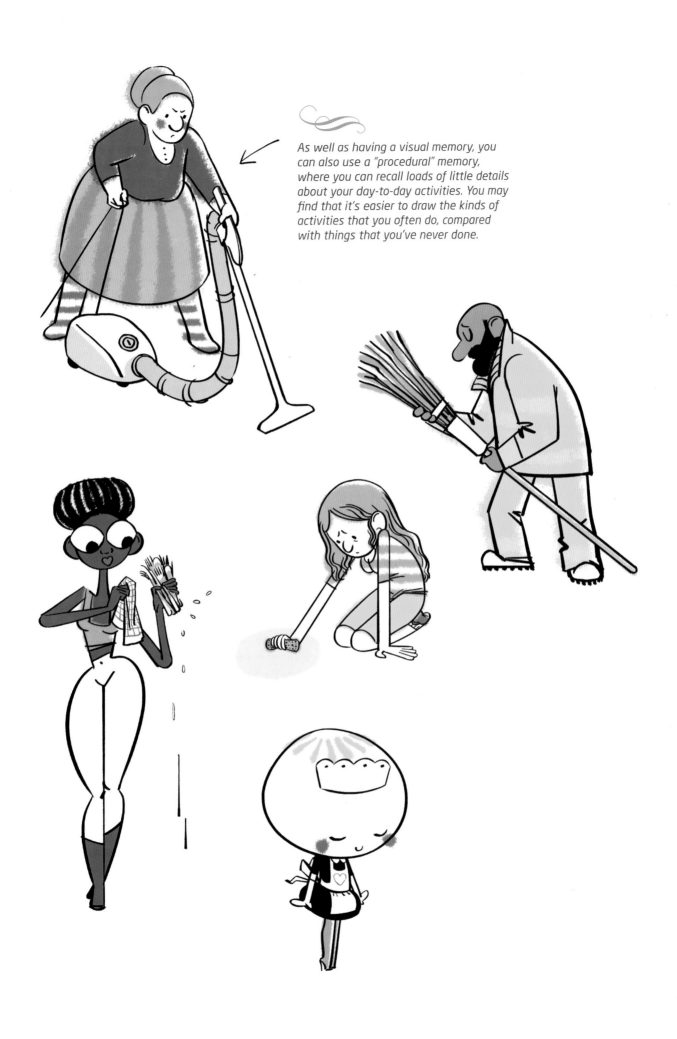

As well as having a visual memory, you can also use a "procedural" memory, where you can recall loads of little details about your day-to-day activities. You may find that it's easier to draw the kinds of activities that you often do, compared with things that you've never done.

Making MUSIC

1 Start with a head, including the lower jaw.

2 Then the neck and body, which is really small compared with the head, to maximize cuteness.

3 Now the limbs. Not easy! Watch out for the foreshortening. It may help to think about the limbs as cylinders, but be ready to cheat to get the kind of drawing you want.

4 Finally, complete the look: this one's a mini-accordionist.

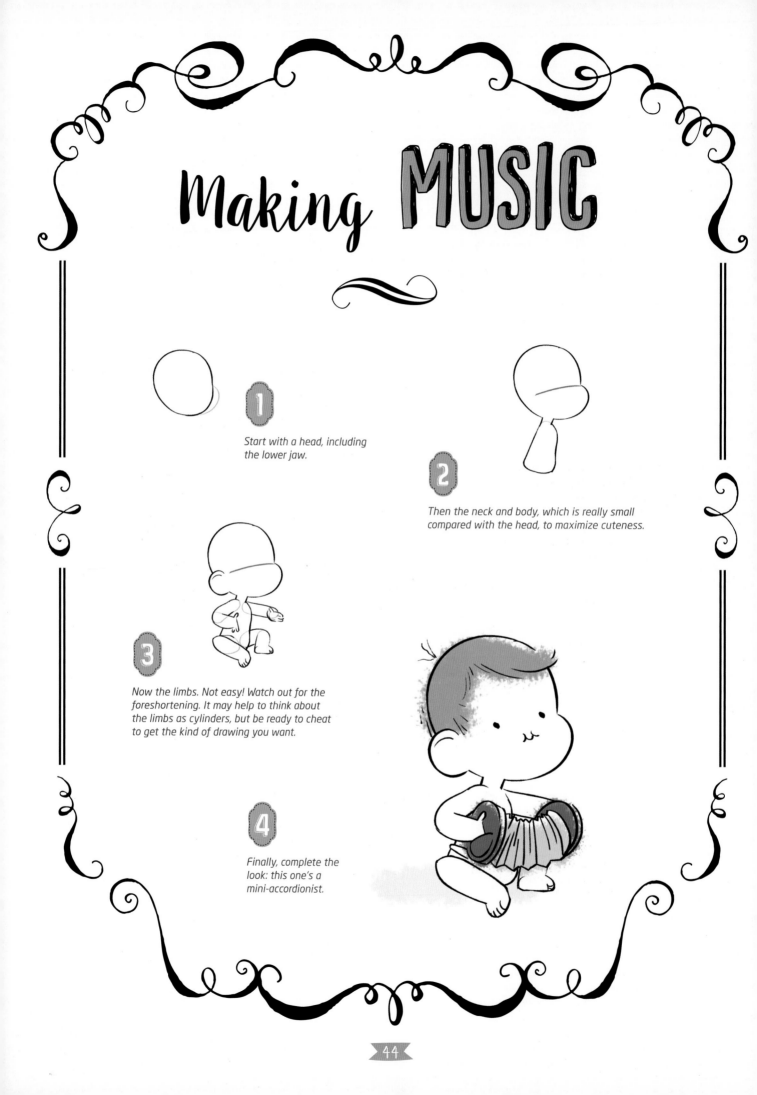

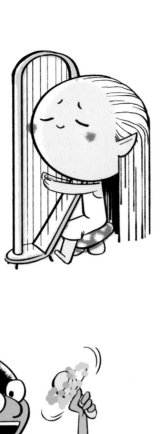

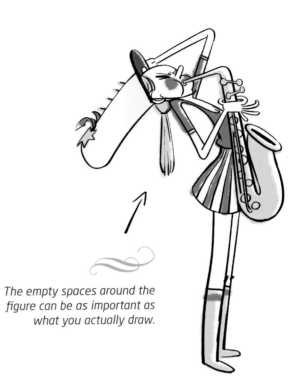

The empty spaces around the figure can be as important as what you actually draw.

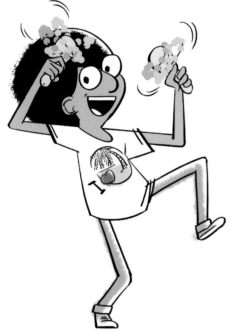

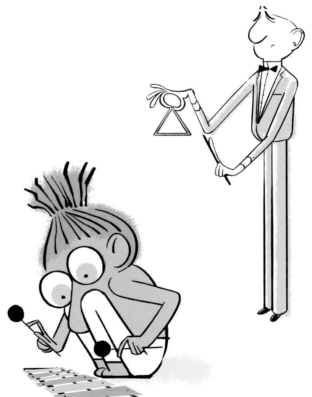

You can also play around with a compact pose like this to make it really expressive.

FIGHTING fit

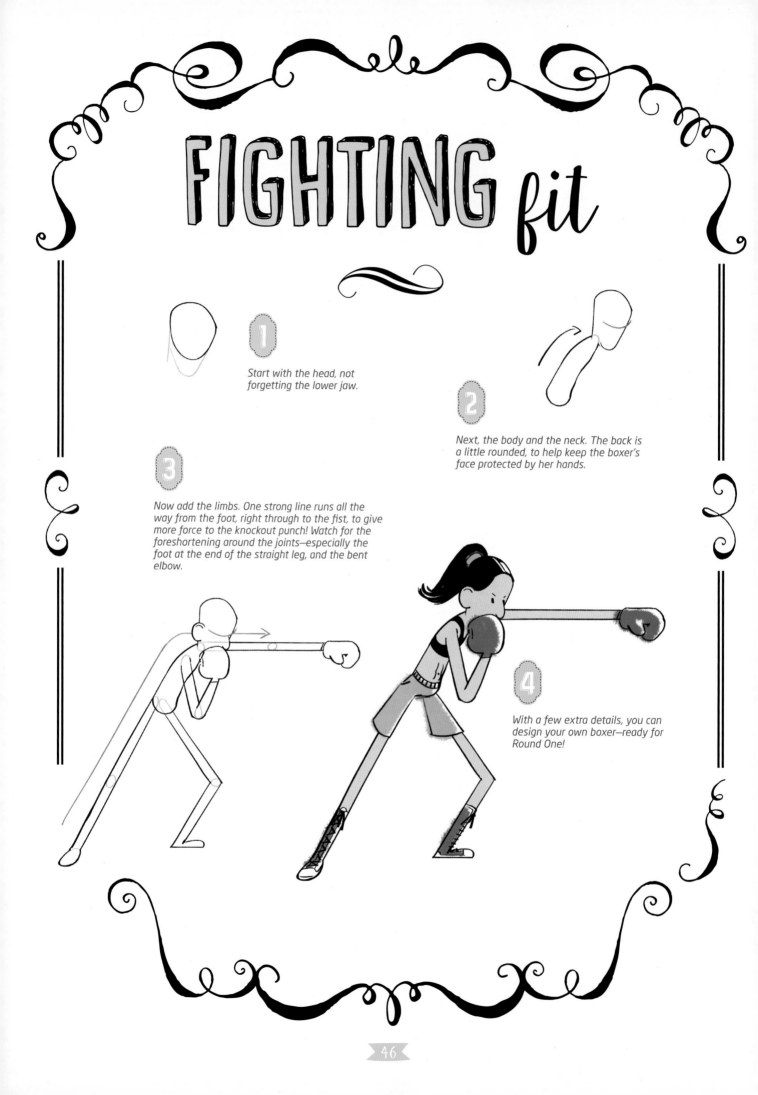

1 Start with the head, not forgetting the lower jaw.

2 Next, the body and the neck. The back is a little rounded, to help keep the boxer's face protected by her hands.

3 Now add the limbs. One strong line runs all the way from the foot, right through to the fist, to give more force to the knockout punch! Watch for the foreshortening around the joints—especially the foot at the end of the straight leg, and the bent elbow.

4 With a few extra details, you can design your own boxer—ready for Round One!

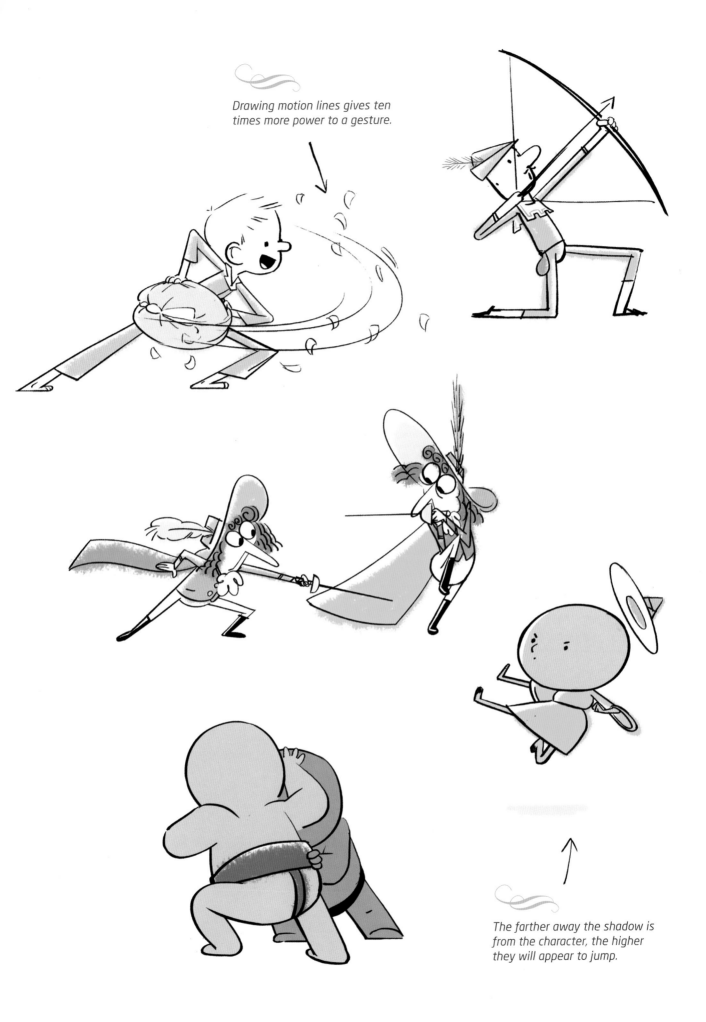

Drawing motion lines gives ten times more power to a gesture.

The farther away the shadow is from the character, the higher they will appear to jump.

Drawing with LOVE

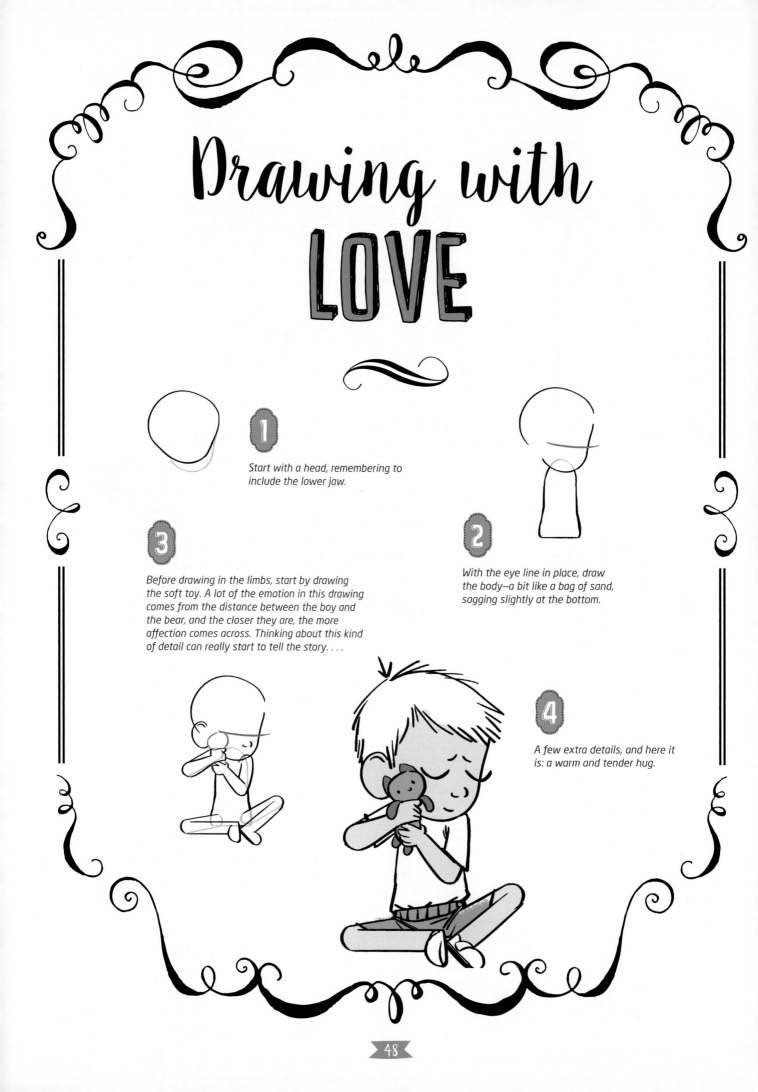

1

Start with a head, remembering to include the lower jaw.

2

With the eye line in place, draw the body—a bit like a bag of sand, sagging slightly at the bottom.

3

Before drawing in the limbs, start by drawing the soft toy. A lot of the emotion in this drawing comes from the distance between the boy and the bear, and the closer they are, the more affection comes across. Thinking about this kind of detail can really start to tell the story. . . .

4

A few extra details, and here it is: a warm and tender hug.

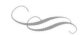

These two lovers seem really made for each other!

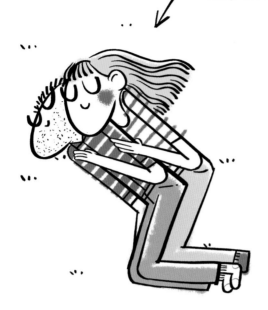

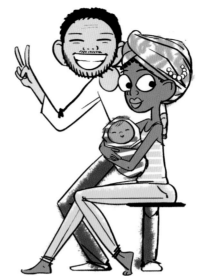

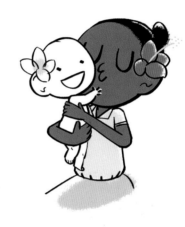

When you draw a group of characters, you don't need to draw every single detail. Just keep to the essentials. By drawing only what you think is important, you allow the drawing to "breathe" and you can direct the viewer to the important part.

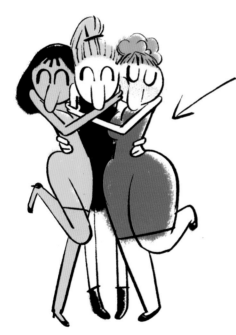

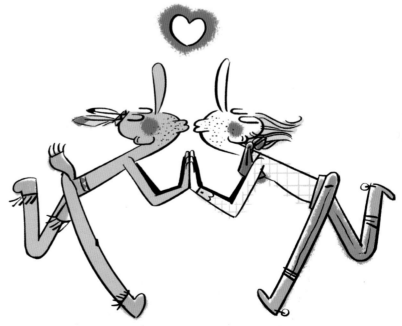

PRACTICE SPACE
for sketching